IMAGES
of America

HUEY P. LONG BRIDGE

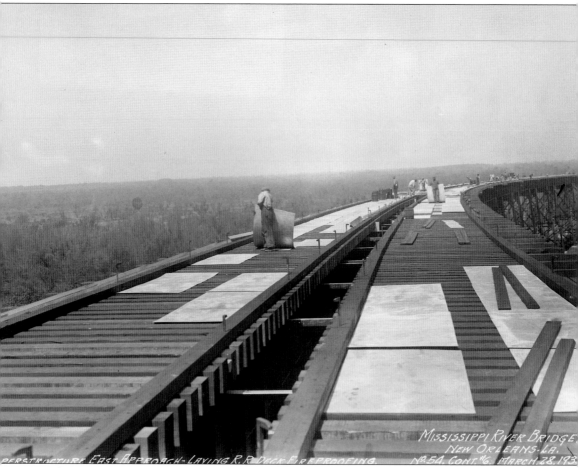

MISSISSIPPI RIVER BRIDGE,
NEW ORLEANS-LA.
PERSTRUCTURE EAST APPROACH-LAYING R.R DECK FIREPROOFING Nº 54. CONT #6 MARCH 28.193.

"Ol' Man River Bows to Engineers' Skill Beneath Mighty Bridge at New Orleans" is the headline of the December 20, 1935, *Syracuse Herald*. Contractors employing innovative construction methods made the engineers' plans a reality as the railroad trestle rose over the swamplands and batture of the Mississippi River in Jefferson Parish. (New Orleans Public Belt Railroad.)

ON THE COVER: The American Bridge Company was the contractor responsible for building the steelwork, or superstructure, for the main portion of the bridge. Workmen are erecting the steelwork span between Piers C and D on the east bank of the Mississippi River. These were the last two piers in the contract for the main bridge, with Pier D connecting the main bridge to the approaches. Railroad spur lines such as the one these men are walking on were constructed throughout the project site to move materials and equipment and to serve as a surface on which cranes would raise and place steel members. (New Orleans Public Belt Railroad.)

IMAGES
of America

HUEY P. LONG BRIDGE

Tonja Koob Marking and Jennifer Snape

ARCADIA
PUBLISHING

Published by Arcadia Publishing
Charleston, South Carolina

Printed in the United States of America

Library of Congress Control Number: 2013930358

For all general information, please contact Arcadia Publishing:
Telephone 843-853-2070
Fax 843-853-0044
E-mail sales@arcadiapublishing.com
For customer service and orders:
Toll-Free 1-888-313-2665

Visit us on the Internet at www.arcadiapublishing.com

To Jack, boy-engineer extraordinaire
To my parents, thank you for your love and support

CONTENTS

ACKNOWLEDGMENTS

The New Orleans Public Belt Railroad generously allowed us to use its photograph archive to create this book. Mike Dumas, chief engineering officer, was wonderful to work with from day one of this effort. We can honestly state that this book would not have been possible without him. Shane Peck, communications director for the Huey P. Long Bridge Widening Project of the Louisiana TIMED Program, shared additional photographs from his collection, which brought the construction story to the present day. Miles Bingham, American Society of Civil Engineers, Louisiana Section, History and Heritage Committee Chair, provided photographs of the Historic Civil Engineering Landmark dedication ceremony and historic documents that aided in telling this story. We thank each of these men for their support and assistance in bringing this book to fruition.

To those who built the bridge in the 1930s, thank you for your hard work and for building a great structure. And to all of the engineers and contractors who are involved in the widening of the bridge today, thank you for your work in making it much less scary to cross.

Finally, I thank my husband, Travis, who loves me because of my nerdiness, not in spite of it. And thank you, to Josh, for your insight into bridge construction.

INTRODUCTION

In a city like New Orleans, surrounded on many sides by bodies of water, bridges form an important connection between the city and surrounding communities for the transportation of people and goods. City planners, politicians, engineers, and businessmen had been envisioning a connection across the lower Mississippi River near New Orleans since 1892, when planners began laying out the possibilities of a railroad bridge between the east and west banks near New Orleans. Newspaper articles discussed technical options regarding location, size, cost, and height of the new bridge, and commented on how the city and surrounding areas would economically benefit from a railroad bridge.

In 1935, the Huey P. Long Bridge opened across the Mississippi River just upstream of New Orleans. It was the longest railroad bridge in the world. Prior to the "Huey P," as locals call the bridge, rail traffic crossed the Mississippi River at New Orleans on ferries. Railroad workers disassembled individual cars from the train, transferred them to ferries, and reassembled the train on the opposite bank. Rail traffic wanting to avoid the additional time and expense of ferry crossings routed trains to the closest Mississippi River rail bridge to New Orleans, upstream nearly 200 miles at Vicksburg, Mississippi.

When a downstream Mississippi River railroad bridge was initially conceived in 1892, the soft, deltaic soils and difficult river environment made its construction a near impossibility with existing methods. The final plan, developed 30 years later by bridge engineer Ralph Modjeski, pushed design and construction limits of civil engineering to make the bridge a reality. Bridge engineers still utilize some of Modjeski's ideas almost 80 years later.

At Governor Long's insistence, engineers included a vehicular and pedestrian bridge with the rail bridge. Huey P. Long was a strong supporter of road infrastructure in Louisiana, creating nearly 13,000 miles of paved roads and building approximately 100 bridges as part of his administration's transportation program. Much to the chagrin of modern drivers, road lanes accommodated the smaller vehicles of the 1930s. The lanes were nine feet wide and without shoulders, leading one person to comment that "more prayers have been uttered atop the Huey P. Long Bridge than in all the churches of New Orleans and Jefferson Parish combined." The final bridge included a double railroad track and twin 18-foot roadways with two-and-a-half-foot pedestrian walkways. Impressively, the final cost of the bridge in 1935 was $9,424,981, more than $3 million under its budget of $13 million.

The New Orleans Public Belt Railroad owned, and continues to own, the bridge. This was an unusual arrangement at the time, as most railroad bridges were privately owned by a single railroad company. The Huey P, being owned by a public entity, is available to all rail lines servicing the Port of New Orleans. The bridge continues to be a transportation workhorse in the greater New Orleans area. It remains the longest railroad bridge in the United States, at 22,995 feet (4.35 miles) in length. It presently provides access to the Port of New Orleans for six of the seven major rail carriers in the United States, and every day, approximately 50,000 vehicles cross the 8,076-foot-long roadway portion of the bridge.

In 2011, the American Society of Civil Engineers (ASCE) dedicated the Huey P. Long Bridge as a National Historic Civil Engineering Landmark. The structure joined the Eiffel Tower, the Panama Canal, and the Capitol as one of the fewer than 300 landmarks in the world so designated. To become an ASCE landmark, the Huey P met the following requirements: being at least 50 years old and of national historic civil engineering significance; representing a significant facet of civil engineering history; having made a significant contribution, such as being the first project designed or constructed by a particular method or utilizing some unique or significant construction or engineering technique; and having contributed to the development of the nation or at least a very large region. On September 28, 2012, the Huey P. Long Bridge received its official declaration in a plaque ceremony attended by local and state dignitaries. Huey Long himself even made a dramatic appearance.

Following the dedication ceremony, on October 10, 2012, the Jefferson Parish Council passed the following resolution in honor of the Huey P. Long Bridge:

On joint motion of all Councilmembers present, the following resolution was offered:

RESOLUTION NO. 119663

A resolution commending and congratulating the Huey P. Long Bridge as being designated a National Historic Civil Engineering Landmark by the American Society of Civil Engineers. (Parishwide)

WHEREAS, the American Society of Civil Engineers is holding a dedication ceremony on September 28, 2012; and

WHEREAS, the Huey P. Long Bridge will join fewer than 250 other landmarks around the world with such a designation including the Eiffel Tower, the Panama Canal and the United States Capitol Building; and

WHEREAS, this Council wishes to recognize, commend and congratulate the Huey P. Long Bridge as being designated a National Historic Civil Engineering Landmark by the American Society of Civil Engineers.

THEREFORE, BE IT HEREBY RESOLVED BY THE JEFFERSON PARISH COUNCIL of Jefferson Parish, Louisiana, acting as governing authority of said Parish:

SECTION 1. That this Council does hereby commend and congratulate the Huey P. Long Bridge as being designated a National Historic Civil Engineering Landmark by the American Society of Civil Engineers.

The foregoing resolution having been submitted to a vote, the vote thereon was as follows:

YEAS: 7 **NAYS: None** **ABSENT: None**

The resolution was declared to be adopted on this the **10th day of October, 2012.**

One

NEED AND PLAN
FOR A BRIDGE

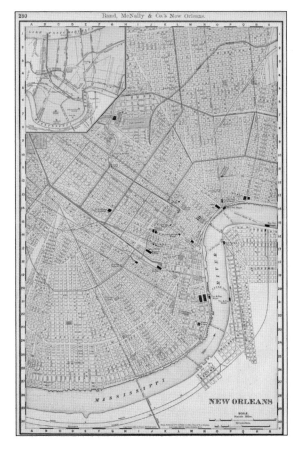

In 1895, American commerce centered on the Mississippi River. Agricultural goods from throughout the Mississippi, Missouri, and Ohio River valleys floated downstream to New Orleans on steamboats, paddle-wheel boats, and flatboats for distribution to other parts of the country and the world. Despite New Orleans being a transportation center, no bridge united the two banks of the city. Ferries connected the east and west banks of the river, and railroads connected the river to the country. (Authors' collection.)

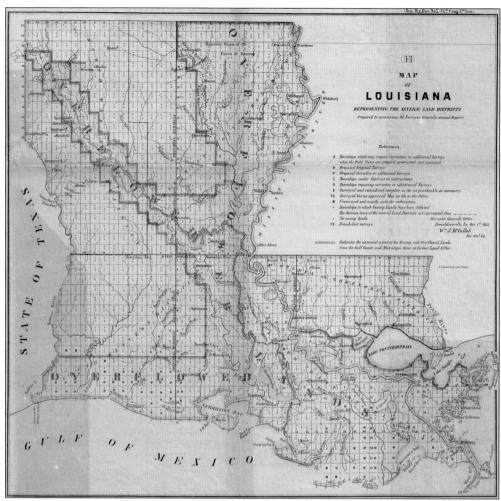

This 19th-century map illustrates the influence of the Mississippi River on Louisiana. Rivers and bayous merged into and diverged from the great river, but no bridge crossed it anywhere in the state. For rail lines leaving the Port of New Orleans with goods destined for Western states, the nearest bridge was in Vicksburg, Mississippi, roughly 200 miles upstream. Those extra miles extended travel times by several days, resulting in increased transportation costs. (Authors' collection.)

The lower Mississippi River itself was the reason for the lack of rail bridges south of Cairo, Illinois. According to Michael M. Palmieri in an April 1995 article in the *Pacific Rail News*, "the upper Mississippi was certainly an inconvenience, but the lower Mississippi was a genuine obstacle. This comparison helps explain why there have been about 40 railroad bridges built across the river between Lake Itasca, Minnesota and Cairo, Illinois, but only five built across the river between Cairo and the Gulf of Mexico." (Library of Congress.)

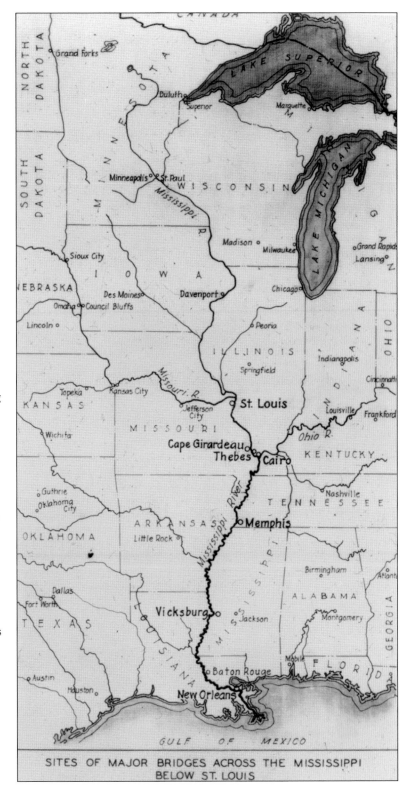

SITES OF MAJOR BRIDGES ACROSS THE MISSISSIPPI BELOW ST. LOUIS

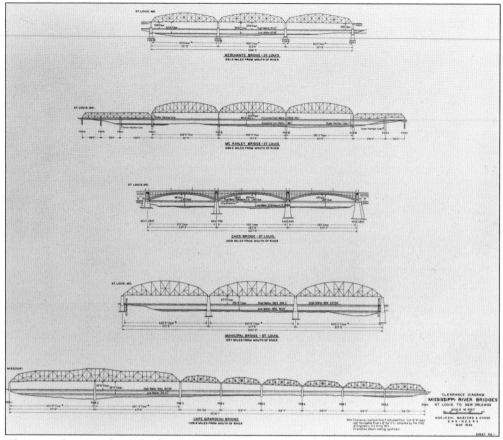

Clearance diagrams drawn by the engineering firm of Modjeski, Masters, & Chase in 1925 compare all of the rail bridges that crossed the Mississippi River between St. Louis and New Orleans. The New Orleans Bridge in the below diagram was never built. Modifications required by the US War Department ultimately changed the location of piers and the clearance of the bridge. Modjeski, Masters, and Chase had extensive experience designing rail bridges in the United States. In 1924, Ralph Modjeski partnered with Frank Masters, who had worked with him between 1904 and 1914 on the Memphis and Louisville Bridges. Later, Modjeski brought Clement E. Chase, who had worked under him on the Benjamin Franklin Suspension Bridge across the Delaware River at Philadelphia, into the partnership under the name Modjeski, Masters, & Chase. The engineering firm continues to this date under the name Modjeski & Masters. (Both, Library of Congress.)

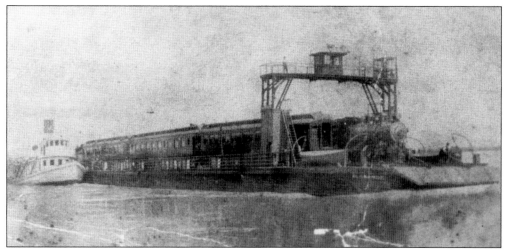

In lieu of traveling 200 miles north to Vicksburg, some railroads chose to ferry their trains across the Mississippi River. Workers uncoupled segments of railcars and loaded them onto specially designed train ferries fitted with rail tracks. Ferries shuttled two to five railcars at a time. Engineers had to wait until the entire length of the train crossed the river, and workers reassembled it on the opposite bank before proceeding to their next station. (State Library of Louisiana.)

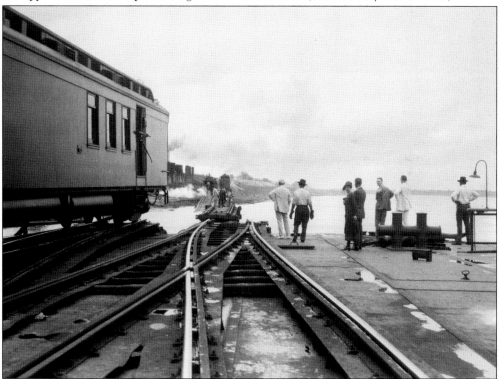

Because of the high demand for train ferries, two or more tracks met at each ferry dock. One set of tracks serviced the train that was disassembling to cross to the west bank of the river, and another set of tracks serviced a train that was reassembling after it crossed to the east bank of the river. In this photograph, both railroad workers and ferry riders await the arrival of the next ferry. (Louisiana State University.)

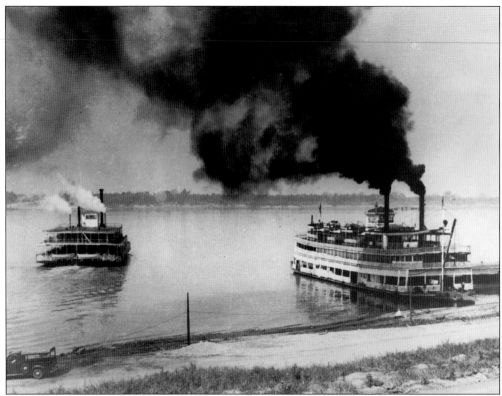

New Orleans was not the only southern Louisiana city that required ferries to cross the Mississippi River. Baton Rouge offered multiple ferries to pedestrian and automobile passengers wanting to travel to and from the Attakapas region of the state. Passengers and vehicles disembarked to unpaved roads on the unprotected side of the levee. High river stages regularly washed out ferry docks, requiring frequent maintenance and repair. (Louisiana State University.)

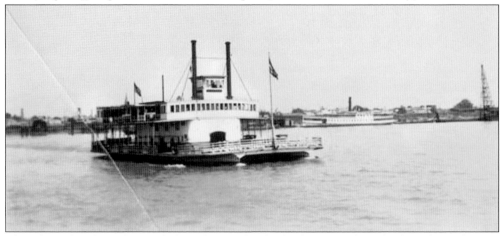

The Algiers ferry brought people from the west bank of Orleans Parish to the foot of Canal Street on the east bank of New Orleans. The Canal Street–Algiers ferry has been in regular service since 1927. For over 200 years, intensive settlement in Algiers extended little beyond Algiers Point. The completion of the Greater New Orleans Bridge, now called the Crescent City Connection, across the Mississippi River in 1958, made new development possible. (New Orleans Public Library.)

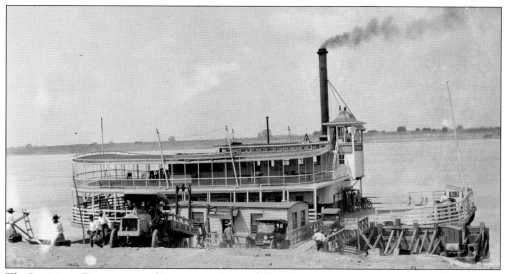

The Louisiana Department of Transportation and Development continues to support ferry service for automobiles and pedestrians across the Mississippi River, just as local and state interests did before the construction of the Huey P. Long and other bridges. Presently, eight ferries and eight bridges cross the river in the state of Louisiana. (Louisiana State University.)

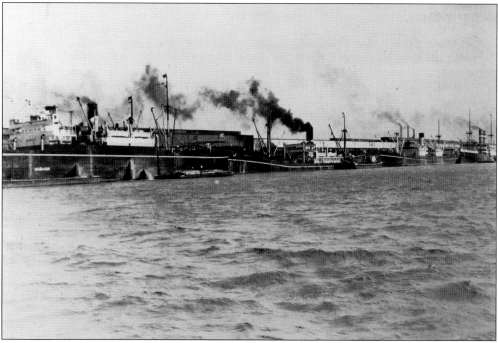

New Orleans has been a center for international trade since Jean-Baptiste Le Moyne, Sieur de Bienville, founded the city in 1717. Bienville wrote to the directors of the Company of the Indies in 1717 that he had discovered a crescent bend in the Mississippi River that he felt was safe from tidal surges and hurricanes and proposed that the new capital of the colony be built there. Nearly 300 years later, the present Port of New Orleans is the only deepwater port in the United States served by six Class I railroads: Burlington Northern/Santa Fe, Canadian National, CSX, Kansas City Southern, Norfolk Southern, and Union Pacific. (State Library of Louisiana.)

Ideally located on the 14,500-mile Mid-American inland waterway system, the New Orleans port throughout its history has handled a diverse cargo, including apparel, food products, consumer merchandise, chemicals, coal, timber, iron, steel, and more than half of the nation's grain exports. Farmers from 32 states and two Canadian provinces have used the Mississippi River and its tributaries to move their agricultural products to New Orleans since the founding of the port. (State Library of Louisiana.)

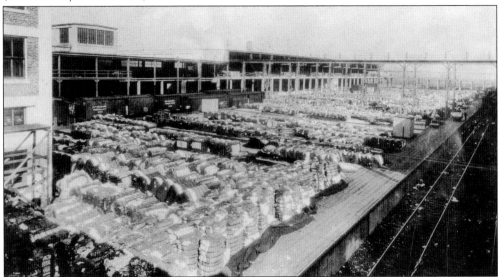

A visitor to New Orleans, James Creecy, wrote in 1834, "With what astonishment did I for the first time, view the magnificent levee, from one point or horn of the beauteous crescent to the other, covered with active human beings of all nations and colors, and boxes, bales, bags, hogsheads, pipes, barrels, kegs of goods, wares and merchandise from all ends of the earth! Thousands of bales of cotton, tierces of sugar, molasses; quantities of flour, pork, lard, grain and other provisions; leads, furs, &c., from the rich and extensive rivers above; and the wharves lined for miles with ships, steamers, flatboats, arks, &c. four deep!" (State Library of Louisiana.)

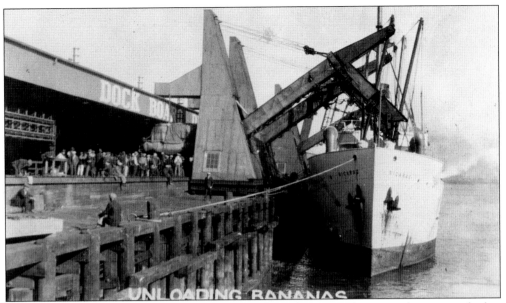

According to the Louisiana State Museum, "since the mid-nineteenth century, bananas and other tropical fruits have made up a significant portion of the New Orleans import trade. The United Fruit Company in particular has been an important purveyor of tropical commodities since the 1890s. Until they moved most of their operations to Mississippi in the mid-Sixties, the United Fruit Company unloaded the ships of their 'Great White Fleet' just upriver from the coffee docks." (State Library of Louisiana.)

In 1942, coffee was one of the oldest and principal commodities that came to the port, and it continued to be an integral part of the port's commerce, despite the exigencies of wartime shipping. The Poydras wharf, the long-designated coffee wharf of New Orleans, continued to receive the 132-pound bags in large quantities. As in the early decades of the 20th century, New Orleans is still the nation's premier coffee-handling port. (State Library of Louisiana.)

Moving all of the goods entering the Port of New Orleans for distribution throughout the country required extensive coordination between rail lines, warehouses, and trunk lines. Where feasible, port trunk-line trains would pre-position dockside to facilitate quick transferring of goods to free wharf space for the next incoming vessel. (State Library of New Orleans.)

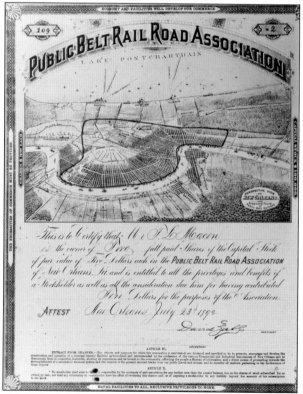

The Public Belt Rail Road Association issued two shares of stock to a Mr. Macon on July 23, 1872. The association was raising capital to fund the Public Belt Railroad of New Orleans, to provide "equal facilities to all, exclusive privileges to none." The stock certificate includes a perspective view of New Orleans with proposed routes along the Mississippi River from Audubon Park to the Ninth Ward and circling to the back of the city behind the fairgrounds and City Park. (Library of Congress.)

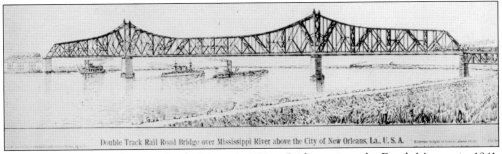

According to the *Final Report for the Mississippi River Bridge*, written by Frank Masters in 1941, the Southern Pacific Railway proposed a high level bridge as early as 1892. E.L. Corthell prepared the design for this bridge, assisted by E.H. Connor. "However, the financial depression of 1892 prevented realization of the project. The continuing growth of traffic and the development of the Public Belt Railroad System led to various proposals by many sponsors for constructing crossings. Because of the difficult foundation conditions and the low lands combined with the navigation clearances required, together with the hazards of construction, the crossing became costly, and a pioneering engineering problem of the first magnitude." (Library of Congress.)

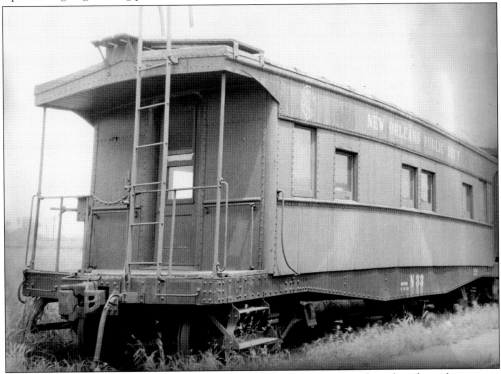

A 1921 source, *Reference-Digest of Industrial Switch Track Ordinances*, describes the rail system in New Orleans: "Conspicuous among the agencies contributing to the commercial development and expansion of New Orleans are traffic facilities afforded by the industrial switch track. This branch of steam railroad service now skirts practically the entire east bank river front of the City, between the dividing lines of the Parishes of St. Bernard and Jefferson, a distance of approximately twelve miles—not to mention immense inland facilities controlled by trunk lines entering New Orleans and those of the local Public Belt Railroad Commission, operating the 'Public Belt,' the only municipally owned railroad of its kind in the United States." (New Orleans Public Belt Railroad.)

Operators and engineers had to be keenly familiar with every switch in the cars and on the tracks to navigate the interconnected termini of major rail lines in New Orleans. This circumstance is described in 1944 in the *Report on Proposed Railroad Grade Crossing Elimination and Terminal Improvement for New Orleans, Louisiana.* "The key location of New Orleans as a principal terminal for railway systems radiating north, west, and east, and the relatively small industrial development of the city combined, result in an unusually large proportion of the freight brought into the city being interchanged between the carriers." (New Orleans Public Belt Railroad.)

Railroad crossings at city streets became frequent sights in New Orleans with the development of the Public Belt Railroad. Intersections like the one pictured here grew into transportation hubs with train depots, bus service, and gas stations to address the traveling needs of passengers and rail workers. (New Orleans Public Belt Railroad.)

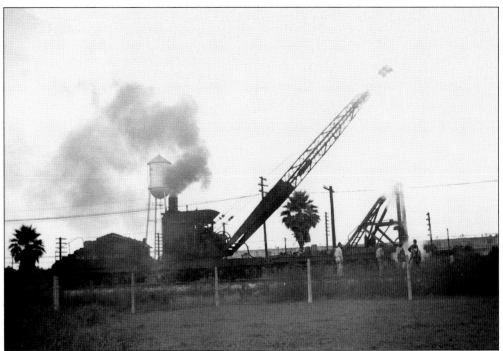

Coal-powered steam cranes were a necessity for maintaining the integrity of highly used tracks. In the early days of the railways, locomotives and rolling stock were small enough to be re-railed manually using jacks and tackle, but as they became bigger and heavier, this method proved inadequate. Appearing about 1890, the cranes soon increased in size, commensurate with the rise of steel Pullman cars. By 1910, cranes reached their peak of development. Many early-era cranes were so useful and powerful that they remained in service until the 1980s. (New Orleans Public Belt Railroad.)

Rail hoists and loading pulleys located trackside made handling materials en route to their destinations more efficient. Workers could shift cargo as needed to accommodate changes in shipping conditions or take on additional loads prior to arriving at the train ferry docks. (New Orleans Public Belt Railroad.)

Switch houses of the Public Belt were active locations along the tracks surrounding the city. In the 1944 *Report on Proposed Railroad Grade Crossing Elimination and Terminal Improvement for New Orleans, Louisiana*, Godat and Heft state, "The railroads serving New Orleans have been one of the principal factors contributing to its development and growth. . . . In addition to the trunk lines, there is the municipally owned Public Belt Railroad, which was built principally to provide switching services to the Port. All trunk lines entering New Orleans terminate here—none operates through the city." (New Orleans Public Belt Railroad.)

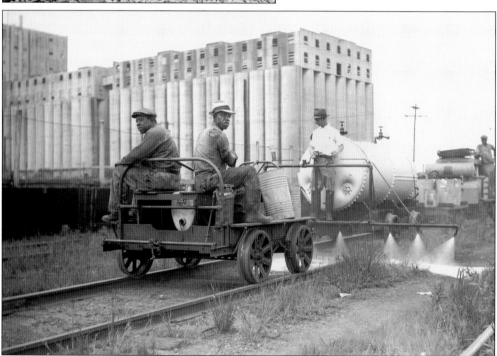

Vegetation control has been a critical maintenance issue for rail tracks in south Louisiana. The subtropical climate and average 60 inches of rainfall each year create a year-round growing season for grasses and shrubs. Heavy doses of herbicides kept tracks clear of plants, reducing potential derailments. (New Orleans Public Belt Railroad.)

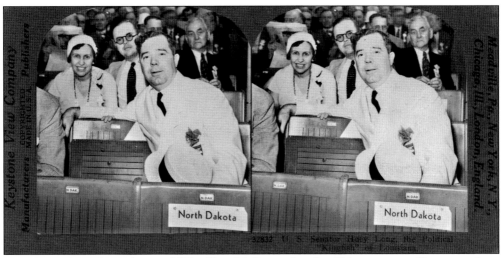

North Dakota

North Dakota

32832 U. S. Senator Huey Long, the Political "Kingfish" of Louisiana.

Huey Pierce Long Jr., nicknamed "The Kingfish," served as the 40th governor of Louisiana from 1928 to 1932 and as a US senator from 1932 to 1935. To stimulate the economy, Long advocated federal and state spending on public works, schools and colleges, and old-age pensions. As governor, he expanded state highways, hospitals, and educational institutions. Long died on September 10, 1935, three months before the bridge that honors his name opened to the public. (Library of Congress.)

The Mississippi River Bridge at New Orleans, renamed the Huey P. Long Bridge, is located in Jefferson Parish, approximately midway between Nine and Twelve-Mile Points upstream from New Orleans at Mississippi River Mile 106. As seen in this early map, public and private entities built additional rail tracks and roads to route people and products over the bridge. (Library of Congress.)

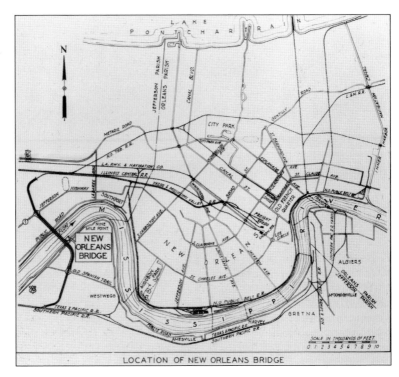

LOCATION OF NEW ORLEANS BRIDGE

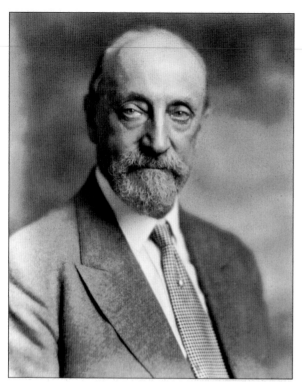

Ralph Modjeski was born in Cracow, Austrian Poland, on January 27, 1861. He received a civil engineering degree from l'École nationale des ponts et chaussées in Paris, France, in 1885. Modjeski was the design engineer and the head of Modjeski, Masters, & Case. He had constructed five bridges across the Mississippi before designing the bridge at New Orleans. Modjeski divided his time between the span at New Orleans and his designing and supervising contract for the $62 million bridge across the Golden Gate at San Francisco. (New Orleans Public Belt Railroad.)

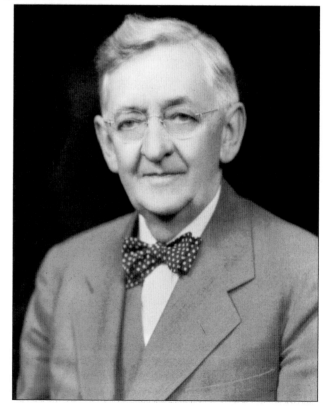

Franklin M. Masters was born in Meryersdale, Somerset, Pennsylvania, on June 18, 1883. He attended Cornell University for one year and then worked with Ralph Modjeski in Pittsburgh on the Bismark Bridge. Over the next few years, Masters worked on multiple bridges throughout the country and helped Modjeski establish offices in Pittsburgh and New York. In 1926, he became a partner with Modjeski, and in 1931 he became the vice president and treasurer of Modjeski, Masters, & Chase. (New Orleans Public Belt Railroad.)

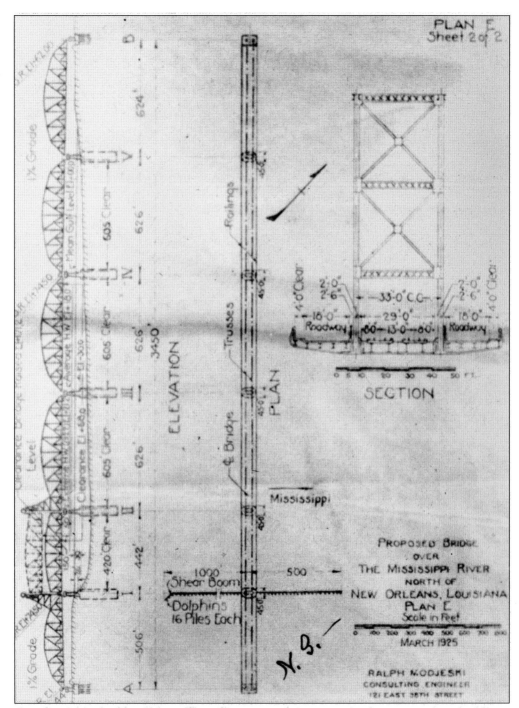

An editorial in the *New Orleans Times-Picayune* explains one citizen's concerns about building a bridge above the city of New Orleans, rather than downstream of the city, and its impact on river traffic: "No continuous span bridge should be permitted that will not allow . . . the chimneys of the large steamboats . . . to pass freely without danger of striking. The steamboat business of this city is of the highest importance." (Library of Congress.)

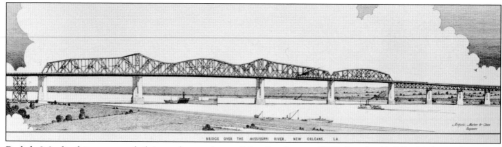

Ralph Modjeski proposed this early version of the bridge in 1925 for the Public Belt Railroad as part of an application for a US War Department permit for a low-level bridge over the Mississippi River. This bridge consisted of six spans, with one span that could be raised for ship traffic. The War Department ultimately rejected the early plans for want of more vertical clearance at higher river stages. (Library of Congress.)

The decline of the stock market in 1929, among other factors, sparked the Great Depression in the United States and around the world. As the 1930s began, one out of every four wage-earners—more than 15 million men and women—was without work. Workers in the New Orleans area were encouraged by the news that over $13 million would be spent on a new bridge. (Louisiana TIMED Program.)

Two

CONSTRUCTING

THE APPROACHES

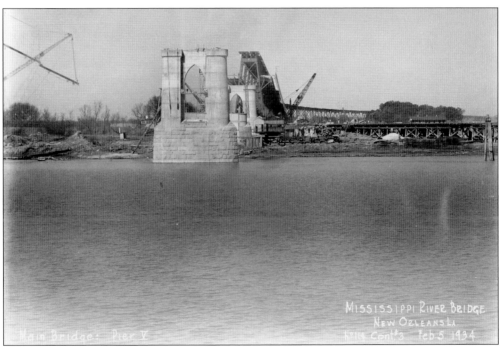

After the design of the bridge was complete, the state solicited bids for four contracts for its construction. The opening of the sealed bids occurred on September 15, 1931. An important group of people reviewed the bids, including Gov. Huey P. Long, O.K. Allen (chairman of the State Highway Commission), T. Semmes Walmsley (New Orleans mayor and president of the Public Belt Railroad Commission), and Robert Barclay (chief engineer of the Public Belt Railroad). (New Orleans Public Belt Railroad.)

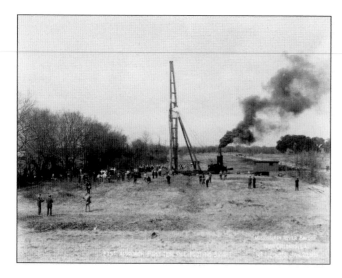

One of the first tasks for constructing the bridge across the swamp was determining the load that the piles could carry in the gumbo soil conditions. Shown here is the driving of the first test pile, with a large crowd observing the initiation of construction on January 20, 1933. The contract for the construction of the substructure for the approaches was signed on December 30, 1932, and work began the next day with the clearing of the right-of-way. (New Orleans Public Belt Railroad.)

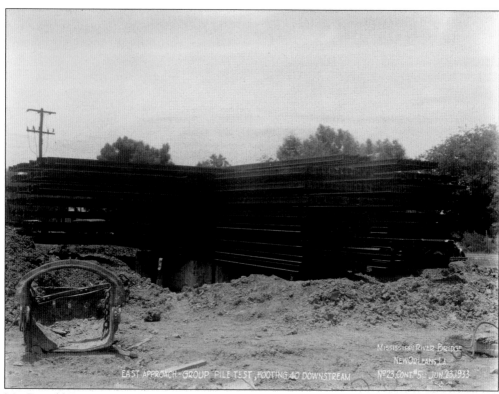

MacDonald Engineering Corporation of Chicago was awarded the contract for the substructure on the approaches. After driving the test piles, the firm applied a load of 20 tons per pile to each group of piles to determine how much weight it could hold. With those test results, engineers were able to determine the necessary pile length. This test took place on piles on the east approach, which is the ramp on the east bank of the Mississippi River in Elmwood, Louisiana. (New Orleans Public Belt Railroad.)

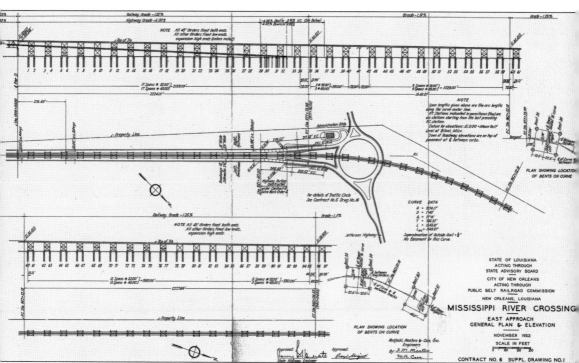

The design plan for the east approach details the orientation of the piles, footings, pedestals, and structural steel for the automobile and train approaches. Pile driving for the east approach was sublet to E.A. Whitney & Sons. According to an article in the *New Orleans Times-Picayune*, 40,000 tons of structural steel were used in the construction of the approaches. (Library of Congress.)

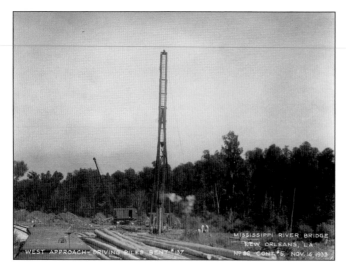

Piles were driven to support the piers for the bridge approaches over the batture land adjacent to the Mississippi River. A stack of timber piles is shown in the foreground. These piles were driven for the west approach, the ramp on the west bank of the Mississippi River in Bridge City, Louisiana. According to an article in the *New Orleans Times-Picayune*, 124,500 linear feet of timber piles were used in the project. (New Orleans Public Belt Railroad.)

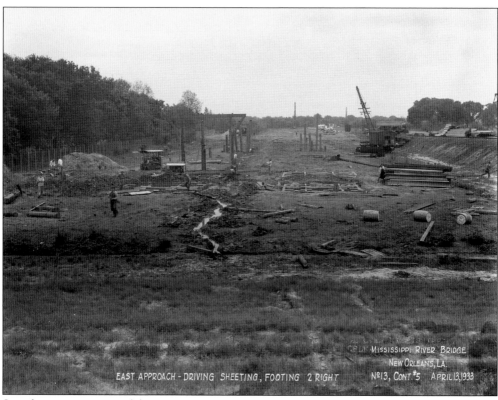

Seen here is a segment of the construction for the east approach of the bridge. One challenge of building the underground portions of the piers was the high groundwater level. A pump transferred groundwater from the excavated area into a drainage ditch that then drained the water away from the construction site. The groundwater level varied throughout the site, and the design elevations of the piles were adjusted in each case so that all piles remained submerged. (New Orleans Public Belt Railroad.)

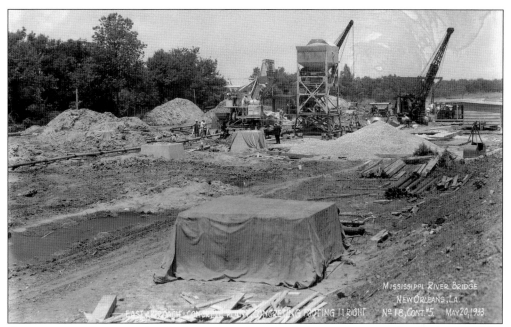

Contractors used concrete batch plants to produce the design concrete mix for the footings. The mobile plant could be stationed in convenient locations throughout the project site, eliminating the need to carry concrete great distances. The concrete mix consisted of cement, water, sand, and aggregate. A bucket on a crane was used to lift the materials into the mixer. (New Orleans Public Belt Railroad.)

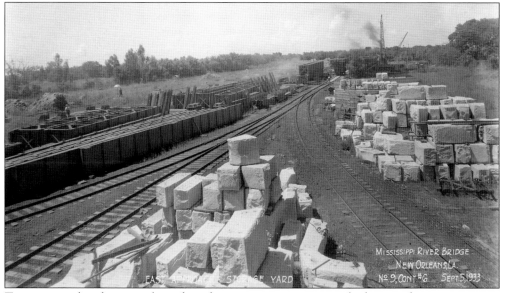

Temporary railroad spur tracks such as this one were important in facilitating the transportation of materials from barges to erection derricks or points of storage. Materials and equipment for construction, including steel trusses, granite blocks, and cranes, were stored in this staging area located near the intersection of multiple railroad tracks. Spur tracks made possible the efficient movement of large amounts of heavy materials throughout the project site. (New Orleans Public Belt Railroad.)

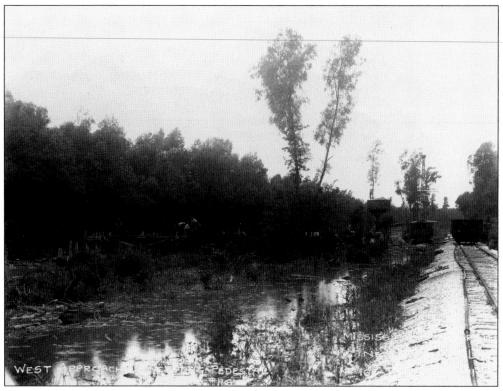

MacDonald Engineering Company workers build a pedestal in a particularly swampy area at the west approach. The company's $496,337 bid to construct the substructures of both approaches includes the following material quantity estimates: 32,400 cubic yards of excavation for the footings; 24,700 cubic yards of concrete in the pedestals, footings, and abutments; 1,120,000 pounds of reinforcing steel; 1,032,200 linear feet of 60-foot-long timber piles; 25,000 cubic yards of highway embankments; 8,000 square yards of bituminous roadway surface; 750 linear feet each of 12-inch and 24-inch diameter concrete pipe; and 5,000 steel driving shoes for piles. (New Orleans Public Belt Railroad.)

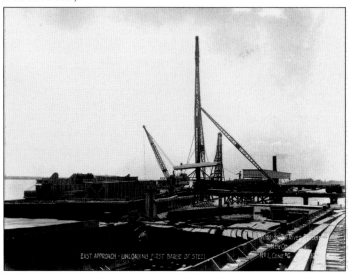

Workers unloaded the first barge of steel for the east approach in June 1933. Railcars carried the steel from river barges to a materials storage area. The barge load shown here contained a variety of pieces, including curved sections, rebar, segments for the railroad decks, and structural members with pre-drilled boltholes. (New Orleans Public Belt Railroad.)

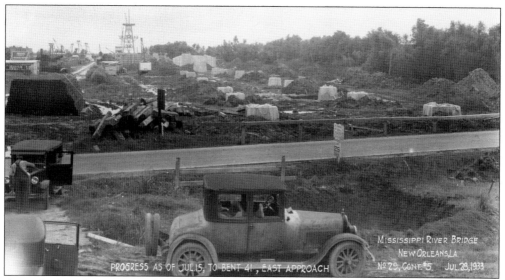

According to the 1941 *Final Report*, "pile driving on the approach substructure contract was started on the East Approach on January 15, 1933; and concreting was started early in May. By June 15, it was possible to notify the approach superstructure contractor to begin work on the first twelve bents, and by October the entire East Approach substructure was completed. West Approach pile driving was started early in July, 1933, and the entire West Approach substructure was completed by May 15, 1934." (New Orleans Public Belt Railroad.)

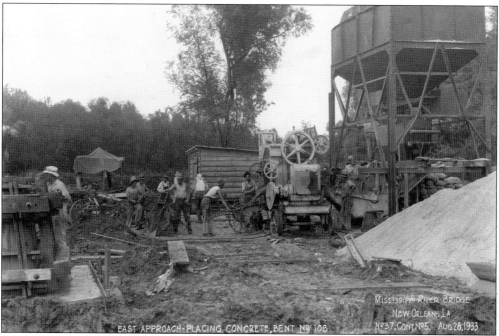

Concrete was mixed in the batch plant and transferred to wheelbarrows for transport to footing locations. This photograph was taken on August 28, 1933, soon after a large strike ended on the project. Before the strike, 700 men were employed to work on the bridge. By Saturday, August 26, 1933, nearly 1,000 men were at work in the construction of the Mississippi River Bridge, according to an article in the *New Orleans Times-Picayune*. (New Orleans Public Belt Railroad.)

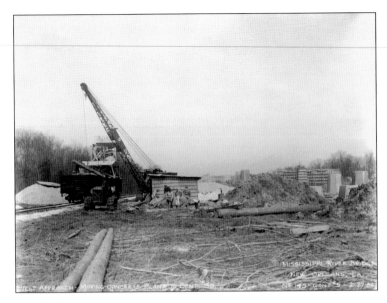

The railroad spur lines through the construction site accommodated the movement of equipment and materials between work areas. This photograph shows the contractor moving a concrete batch plant from one footing location to another on the west bank on February 27, 1934. (New Orleans Public Belt Railroad.)

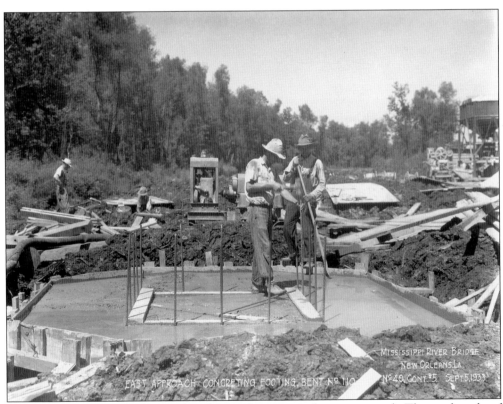

Men place concrete in the formwork at this pier location on the east approach. They set lengths of rebar in the footing in preparation for pouring the pedestal. After the footing cured, or dried, and the formed pedestal was poured and cured on top of it, contractors returned soil to the excavated area. Workers finished by compacting the soil around and on top of the concrete footing. (New Orleans Public Belt Railroad.)

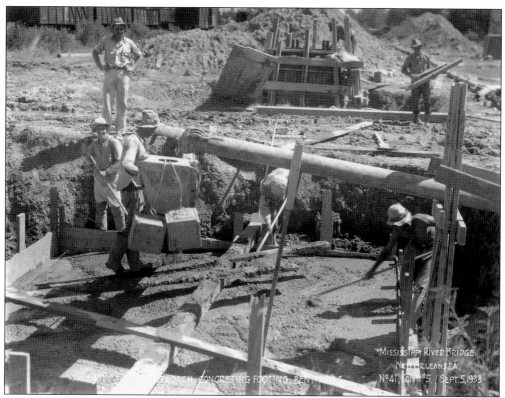

Concrete from the batch plant pours into an accurately located footing. To determine the proper location to construct each footing, surveyors used known points and dimensions from the plans to mark the points at which to build. According to the *Final Report* by Frank Masters, before construction started, three base points were created on the east bank batture. "Raised houses were built over these points, and two crews of instrument men were continuously employed in locating temporary and permanent work, including even the piles in the falsework." (New Orleans Public Belt Railroad.)

On March 22, 1934, concrete was pumped from the concrete batch plant to the west bank footing location through the pipe running across the center of this photograph. The concrete was directed from the pipe into the formwork by a chute. Discarded pile trimmings lie next to the footing excavation awaiting the cleanup crew. (New Orleans Public Belt Railroad.)

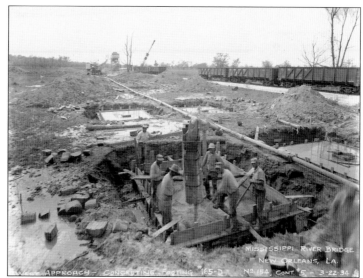

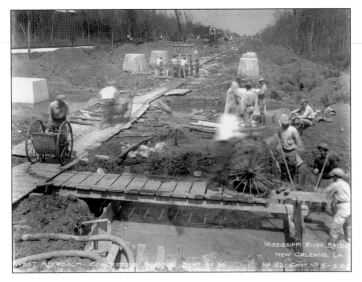

Men used wheelbarrows, or buggies, with large wheels to carry concrete from the batch plant, over the raised platforms, to the footing location. The raised walkways made it possible to get around the construction site without having to directly traverse the swampy soil. Standing water can be seen in some of the excavated areas. Dewatering hoses kept excess water from the footing work areas. (New Orleans Public Belt Railroad.)

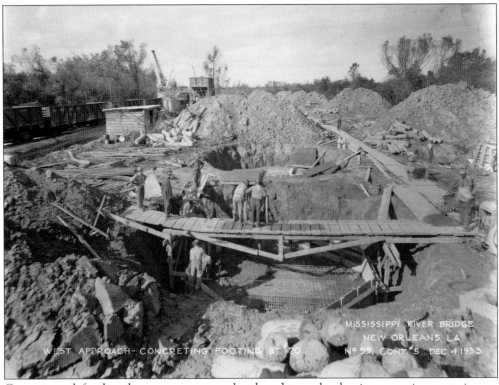

Concrete work for the substructure was completed on the east bank prior to moving operations to the west bank. According to the 1941 *Final Report*, "concrete for about half of the East Approach was transported from mixer to location by pumping through pipes. Temporary interruptions to the work sometimes caused the hardened concrete to block the pipe, with considerable loss of material and delay during the removal of the blocked section of pipe. After many such experiences the contractor changed to the use of buggies." (New Orleans Public Belt Railroad.)

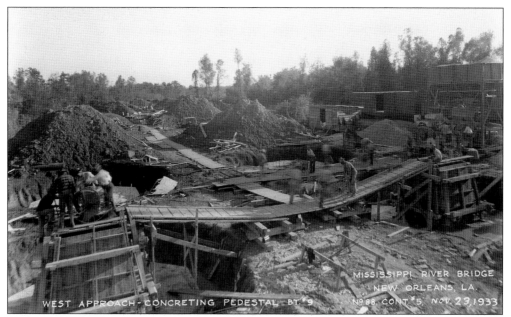

With wooden formwork for the two pedestals in the foreground in place, men carry loads of concrete in wheelbarrows from the batch plant to the pedestal locations. Contractors built walkways and ramps to make wheeling the concrete to the top of the forms easier. Reinforcing steel would have been protruding from the footings beneath the pedestals, into the space in the center of the form. When the concrete was poured into the form, it cured around the reinforcement, connecting the two portions of concrete. After the concrete cured, the wooden forms were removed and possibly reused on other pedestals of similar dimensions. (New Orleans Public Belt Railroad.)

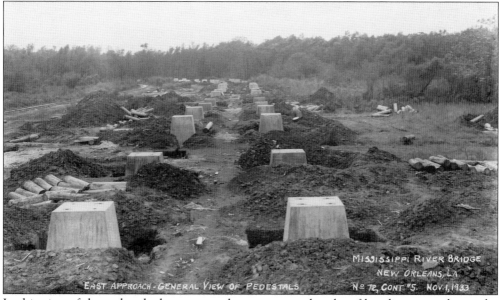

In this view of the pedestals that support the east approach, piles of logs lie scattered near the concrete bases. The logs are trimmings from the piles beneath the footings supporting the pedestals. Each pedestal contained four holes, which were used to connect to the steel structure built on top of the pedestals. (New Orleans Public Belt Railroad.)

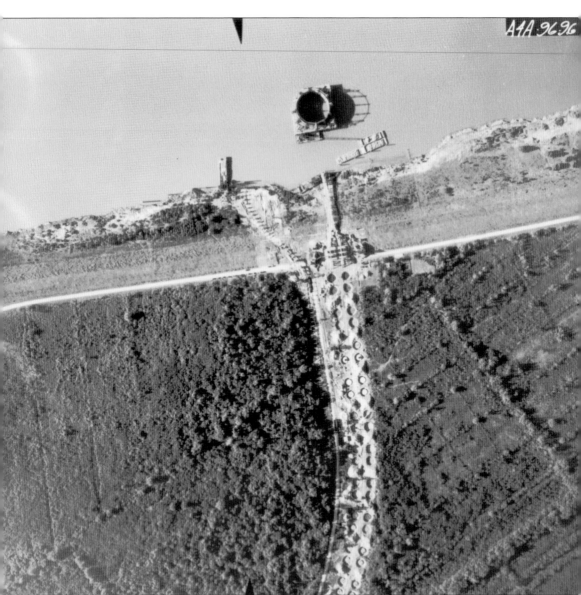

An aerial view of the construction site shows the positions of the footings and pedestals for the approach piers aligned with the piers in the Mississippi River. This scene of the west bank shows the steel shell for the sand island of Pier I being constructed in the river and Pier A being constructed on the land-side of the river levee. (Library of Congress.)

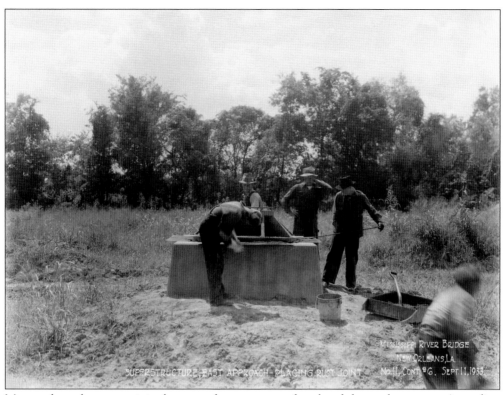

Men work to place a rust joint between the concrete pedestal and the steel structure. According to the 1941 *Final Report*, "the tower shoes, placed well in advance of tower erection, were set on rust joints consisting of a mixture of iron filings, flowers of sulphur, sal ammoniac and water. This material was rammed into place under the shoes to insure full bearing. The joints were later raked out around the edges and carefully pointed with cement mortar." (New Orleans Public Belt Railroad.)

Pier B was constructed on the east bank of the Mississippi River. It was the closest pier to the river that was built on piles rather than on a caisson. The piles in Pier B were driven to a depth of 51.5 feet below Mean Gulf Level. Here, the contractor is constructing a sheet pile wall for the excavation. The willow mattress for Pier V can be seen in the foreground. (New Orleans Public Belt Railroad.)

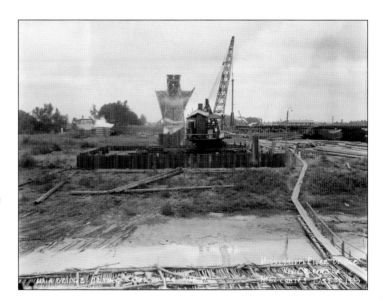

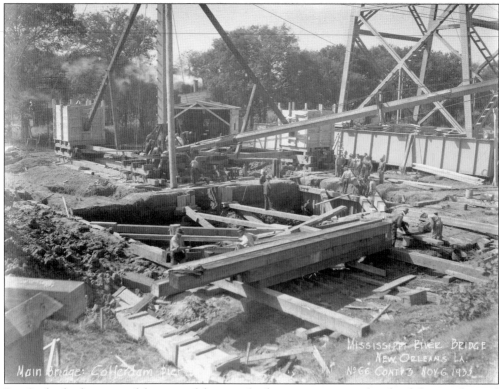

Pier D, the furthest east of the piers of the main bridge, was constructed on land that was beyond the waters of the Mississippi River except at high water levels. Per the design plans, timber piles were driven to a depth of 70.6 feet below Mean Gulf Level for Pier D. A cofferdam was constructed to keep water and soil out of the excavation for constructing the pier. (New Orleans Public Belt Railroad.)

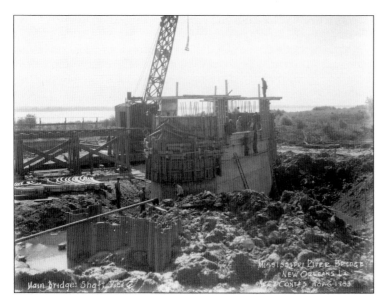

Pier C was the second-easternmost of the main bridge piers. Timber piles were driven to an elevation of 58.4 feet below Mean Gulf Level for this pier. Sheet piles were used to hold back soggy soils while the shaft of the pier was built. Temporary wooden formwork used to shape the concrete can be seen on the sides of the pier. (New Orleans Public Belt Railroad.)

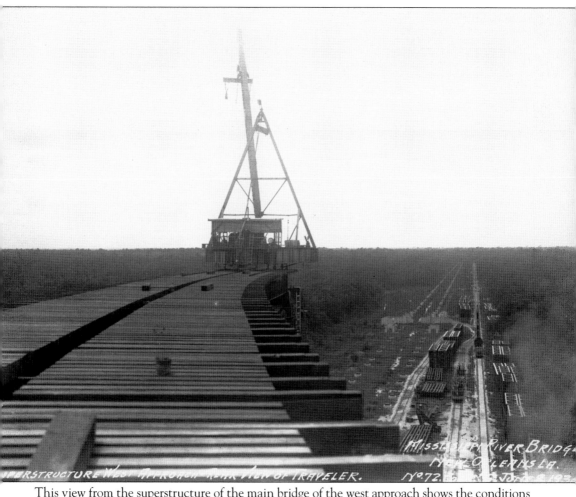

This view from the superstructure of the main bridge of the west approach shows the conditions that were encountered for constructing the footings and piers. Site preparation work included clearing trees and working in soggy soils. According to the 1941 *Final Report*, "erection of the east approach steel was completed late in December, 1933. West Approach erection was begun about the first of March, 1934, and was completed about the middle of October, a year before the last deck span was placed on the Main Bridge." This photograph was taken on June 8, 1934. (New Orleans Public Belt Railroad.)

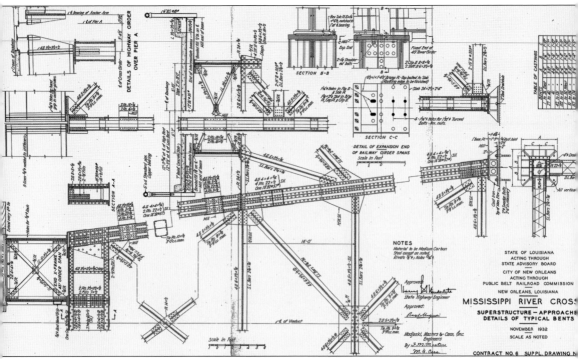

The engineer specified every detail of the bridge construction. This engineering design sheet provided the necessary information for fabricating and assembling bents that supported the highway and railroad approaches. The plan sheet includes details for the size of the steel members, the size and location of holes in the steel, the size of bolts, the size of railroad ties, and the size of the railroad tracks. (Library of Congress.)

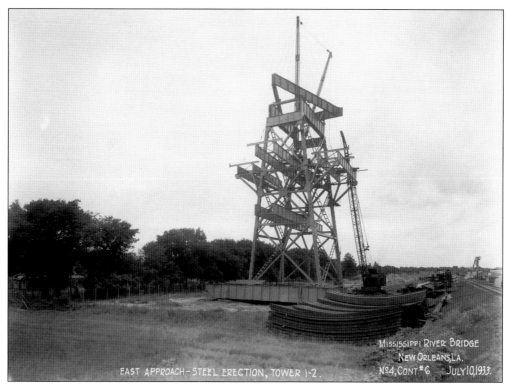

MISSISSIPPI RIVER BRIDGE
NEW ORLEANS, LA.
N°4, CONT.#6 JULY 10, 1933.

EAST APPROACH – STEEL ERECTION, TOWER 1-2.

The McClintic-Marshall Corporation, a subsidiary of the Bethlehem Steel Corporation, submitted the low bid of $3,226,789 for the superstructure of the approaches of the bridge on each bank, according to the *New Orleans Times-Picayune*. The quantities of material McClintic-Marshall estimated for the contract included 78 million pounds of structural metal, 3,500 MBM of treated railway deck timbers, 4,860 cubic yards of concrete roadway slabs, 336,000 pounds of reinforcing steel, and 275,000 linear feet of roadway steel-reinforcing trusses. These photographs show steel erection on the east and west approaches as men and cranes construct truss towers to support the highways and railroad tracks. Steel erection began on the east approach at the end of June 1933. (Both, New Orleans Public Belt Railroad.)

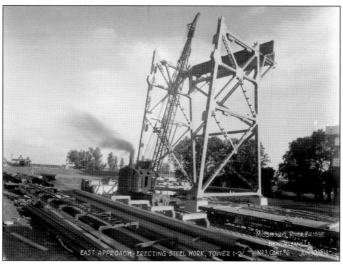

MISSISSIPPI RIVER BRIDGE
NEW ORLEANS, LA.
N°3, CONT.#6 JUN 30 1933.

EAST APPROACH – ERECTING STEEL WORK, TOWER 1-2.

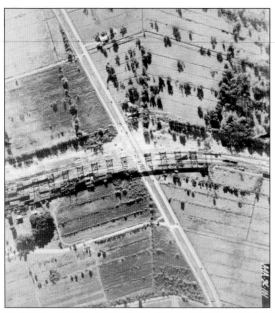

This aerial view likely shows where the bridge approach crosses Jefferson Highway on the east bank of the river. The Mississippi River lies beyond the left side of the view. Pieces of steel are positioned on the ground adjacent to the bridge, ready to be installed. While the bridge was in the planning stages, an article in the *New Orleans Times-Picayune* noted, "the bridge will make the highway approach to New Orleans much more direct, eliminating the sinuous road which winds for many miles along the 30-foot levees." Highways ran up and down both sides of the rivers in Louisiana; with the construction of the Huey P. Long Bridge, there was finally a place to cross over without depending on a ferry. (Library of Congress.)

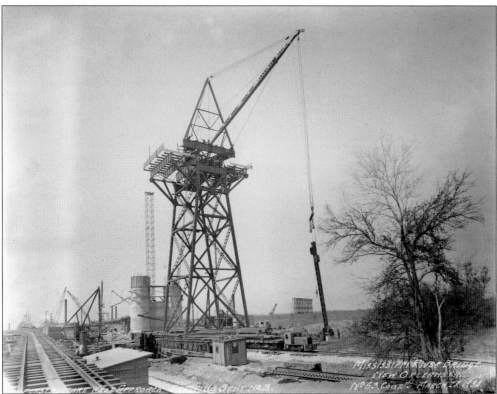

In this photograph, the contractor erects a steel tower near Pier A on the west bank. The workers established a crane, or traveler, on the top of the previously constructed tower to build the next tower in line. Railroad girders were then placed between the two towers so that the traveler could move on to the next tower. Pre-constructed portions of the towers are lined up on the levee in the background. (New Orleans Public Belt Railroad.)

On October 2, 1933, the superstructure on the east approach is progressing from the river toward New Orleans. The crane stationed on top of the railroad tracks progressed down the line as workers erected towers and tracks. The highway approach flanking the railroad approach can be seen in the lower center of the photograph. (New Orleans Public Belt Railroad.)

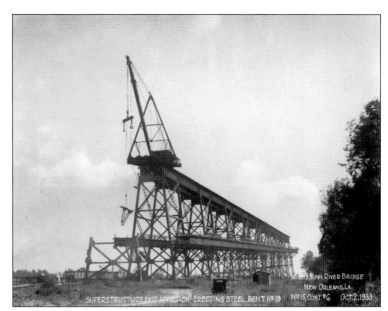

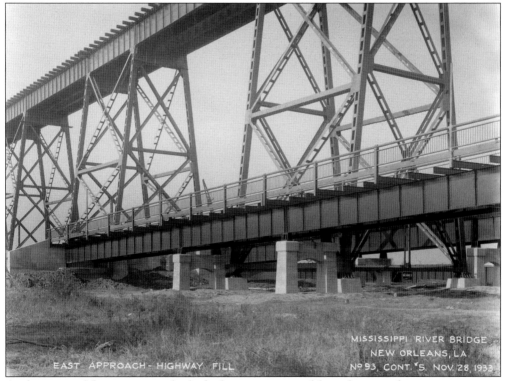

At this point of the east approach, the highway transitioned from the ground to supporting piers. The John Konomos Company, bridge painters, painted the steelwork on the approaches. According to the 1941 *Final Report*, the Konomos firm painted most of the steelwork on the ground before builders erected it. Sun exposure during shipping caused blistering and scaling on large areas of some members, requiring contractors to inspect all of the steel and clean and repaint defective spots. (New Orleans Public Belt Railroad.)

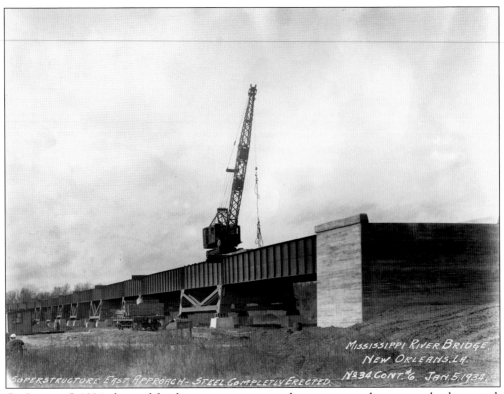

On January 5, 1934, the steel for the superstructure on the east approach was completely erected. The scale of the structural steel members can be seen by the man standing at the bottom of the crane. The railway decks were completed during the winter and spring of 1934–1935, with the laying of the fireproof sheeting as an extra work order. By the summer of 1935, it was possible for the Public Belt Railroad to take over the deck and start laying the rails. (New Orleans Public Belt Railroad.)

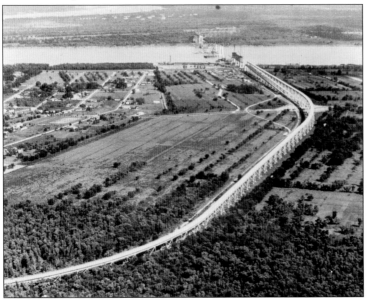

This aerial photograph of the bridge under construction was taken from the east bank looking south toward the west bank. The steel rail section on the east approach is completed and a portion of the bridge deck truss is under construction. Despite setbacks—a strike by bridge workers and delays due to high water—the bridge was constructed within schedule and within the budgeted amount. (Library of Congress.)

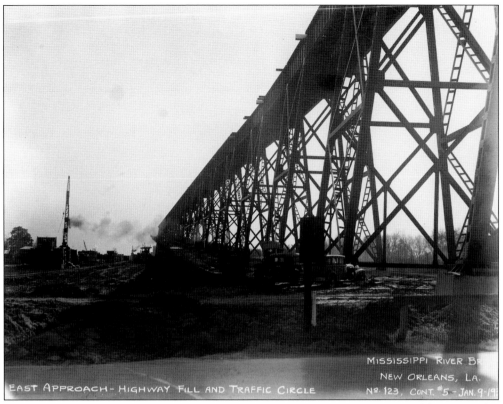

EAST APPROACH - HIGHWAY FILL AND TRAFFIC CIRCLE

Fill dirt was brought in to the site for the portion of the highway not supported by piers. This photograph shows the location where the approach meets the level highway at a traffic circle. The highway traffic circles were added to the substructure contract as an extra work order and were built by the A.N. Goldberg Company. The traffic circles remain today. (New Orleans Public Belt Railroad.)

This sign on the side of the east approach reads "McClintic-Marshall Steel, Huey P. Long Bridge." The McClintic-Marshall Corporation was organized by Howard H. McClintic and Charles. D. Marshall in 1900 in Pottstown, Pennsylvania. By 1930, McClintic-Marshall was the largest independent steel manufacturer in the country. In 1931, Bethlehem Steel acquired the company for $32 million. (New Orleans Public Belt Railroad.)

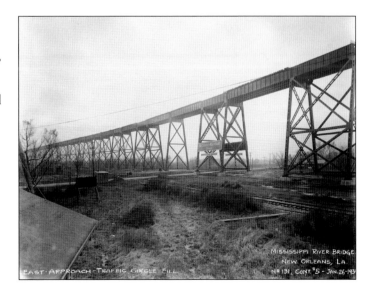

EAST ARPROACH - TRAFFIC CIRCLE FILL.

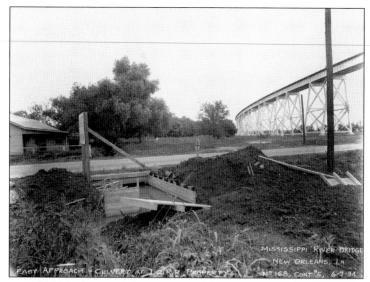

In association with the new roadways constructed to bring traffic to the bridge, new drainage structures were built to accommodate the flow of water across the new infrastructure. This photograph shows a culvert being constructed beneath a roadway in the area of the east approach on Illinois Central Railroad property. (New Orleans Public Belt Railroad.)

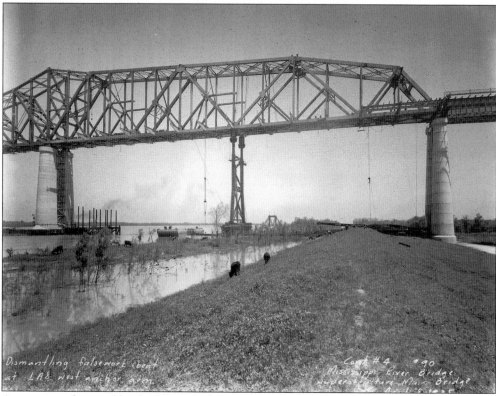

A contractor disassembles the falsework that was temporarily supporting a portion of the structure during construction while cattle graze on the west bank river levees below the bridge. This highway was among the many for which Huey P. Long passed legislation to build in Louisiana. During Long's tenure, Louisiana added 1,583 miles of concrete roads, 718 miles of asphalt roads, 2,816 miles of gravel roads, and 111 bridges to its transportation network. By 1931, Louisiana employed 10 percent of all men working on roads and bridges in the United States. This photograph was taken on April 8, 1935. (New Orleans Public Belt Railroad.)

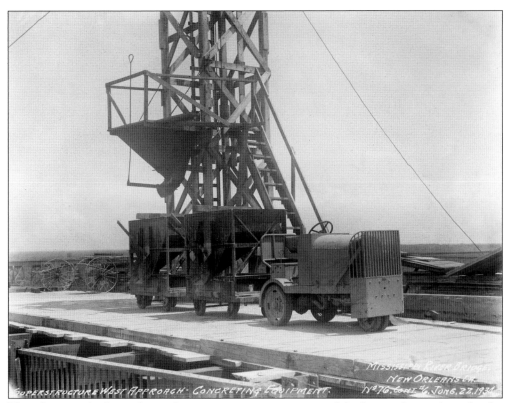

The photograph above shows the concreting equipment used for laying the roadway for the approaches. According to the 1941 *Final Report*, "the concrete roadway slabs are 7 inches thick, reinforced longitudinally with welded bar trusses and transversely with 1/2-inch round bars. Concrete was transported from the plants to place in the forms using small rubber-tired tractors and dump cars of one cubic yard capacity, and was vibrated into place by means of a small air hammer. The surface of the concrete was finished using a screed across the full 18-foot width, then a belt and finally wood floats. In the process, surface irregularities were detected with a ten-foot straight edge. The concrete was cured under wet straw for at least eight days. The concrete mix contained 1.60 barrels of cement per cubic yard, and cylinder tests indicated a strength of about 5000 pounds per square inch throughout the roadway slabs." The photograph below shows the wet straw on top of the concrete slab. (Both, New Orleans Public Belt Railroad.)

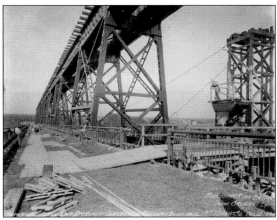

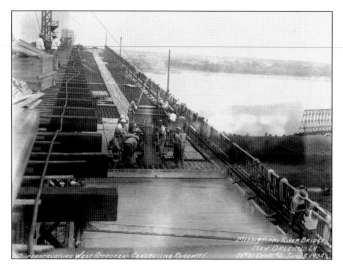

Men place concrete on the roadway deck for the west approach on June 8, 1934. Men moved up the approach, pouring concrete into a grid of reinforcement. One man drove the vehicle, one controlled the flow of concrete down the chute, two kept the concrete moving in the container, and the others ensured that the concrete reached into all of the spaces. In the foreground, men work to keep the wet concrete smooth and consistent. (New Orleans Public Belt Railroad.)

Dump trucks navigate the mucky soil to bring fill for the highway at the west approach. The 1941 *Final Report* states that, "the highway embankment fills were begun by this contractor as soon as possible after the abutments had been placed, so as to give a maximum time for fill settlement before concrete paving was placed. The fill material, obtained from the batture, was placed in thin layers and rolled carefully during a period of frequent rains, and all of the embankments are accordingly very compact." (New Orleans Public Belt Railroad.)

Three

CONSTRUCTING
THE MAIN SPAN

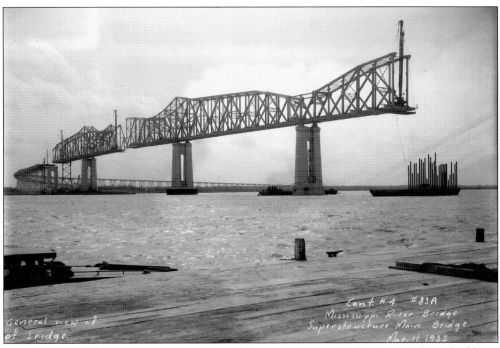

In the decades leading to the construction of the Huey P. Long Bridge, New Orleans had been increasing in importance as an ocean terminal following the opening of the jetties at the mouth of the river, which allowed a larger class of vessels into the port. The *New Orleans Times-Picayune* declared, "during the development of its immense commerce, the railroads terminating in New Orleans have largely increased their business. The river, however, has prevented a prompt and ecumenical interchange of traffic between the railroads." (New Orleans Public Belt Railroad.)

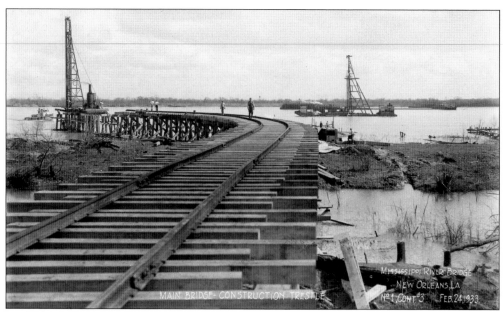

To facilitate the movement of materials and equipment from staging areas on land to barges for construction in the river, contractors built a trestle with a railroad track that extended into the river. The track extended far enough to provide sufficient draft for barges loaded with construction materials. Workers drove piles into the swampy soils adjacent to the river to support the temporary trestle's extension to the required point in the river. (New Orleans Public Belt Railroad.)

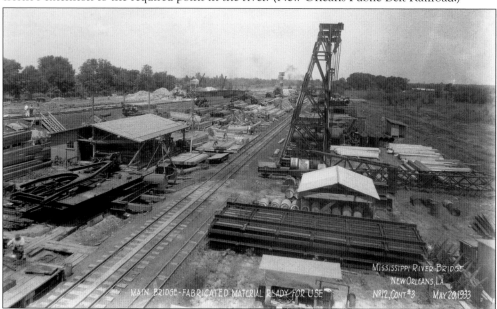

This material staging area held prefabricated bridge members for transportation by rail to a barge at the river, and then to the mid-channel construction site. According to the *New Orleans Times-Picayune*, the main river bridge required 20,000 tons of structural steel for its construction. Additionally, the main bridge design called for 500,092 tons of concrete and 6,000 tons of quarried granite from Carrollton, Georgia, the famous Stone Mountain granite. (New Orleans Public Belt Railroad.)

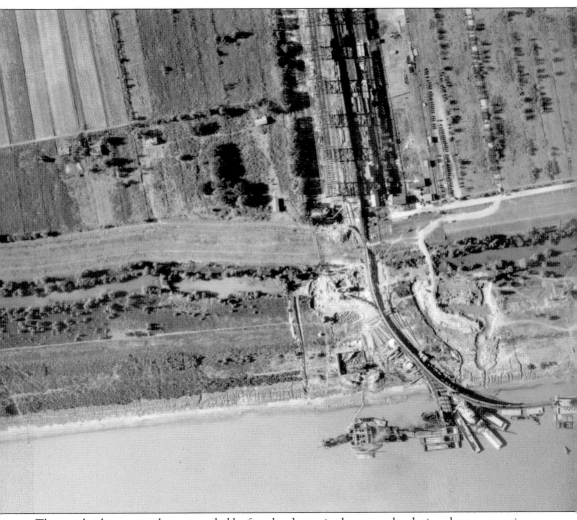

The east bridge approach, surrounded by farmland, required two trestles during the construction of the bridge. Over the next several decades, commercialization of the farmland brought the promised economic development to the east bank of Jefferson Parish. Commercial growth on the west bank took longer to develop. (Library of Congress.)

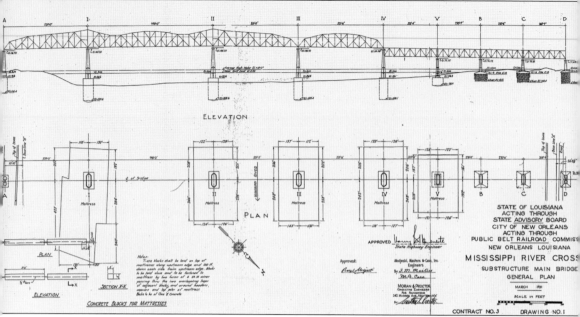

This drawing, revised in March 1936 to show the work as constructed, shows the general plan of the substructure of the main bridge. Piers I, II, III, IV, and V were located within the limits of the river and utilized mattresses and caissons for support. Pier A, on the west bank, was outside of the river and also used a caisson. Timber piles and pile cap footings supported Piers B, C, and D on the east bank. Siems-Helmers Inc. was the contractor for the substructure for the main bridge. (Library of Congress.)

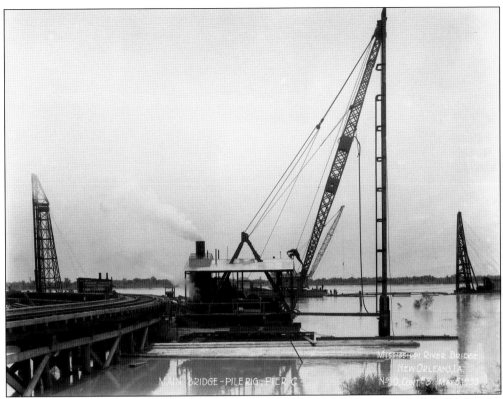

The *New Orleans Times-Picayune* reported that the first pile for the main span of the bridge was driven on January 20, 1933, near the east bank levee. "Among the visitors to the scene . . . was the State Treasurer Jess S. Cave, who turned over a spadeful of earth." This pile supported Pier C for the bridge. According to the design plans, the piles extended to an average elevation of 58.4 feet below Mean Gulf Level. The structure in the background has a sign for W. Horace Williams Co., an engineer and contractor from New Orleans. (New Orleans Public Belt Railroad.)

In addition to driving timber piles for support, contractors drove sheet piles for holding water or soil out of work areas. Sheet piles are long structural sections that interlock vertically, creating a continuous wall. Trees can be seen growing in the river, indicating that the river level was high, most likely greater than an elevation of 18 feet above Mean Gulf Level. This photograph was taken on June 2, 1933. (New Orleans Public Belt Railroad.)

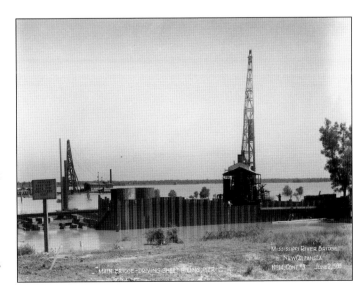

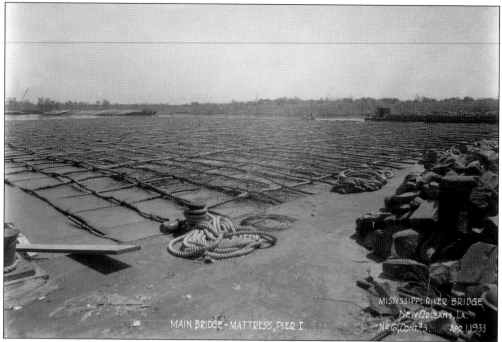

Piers I, II, III, IV, and V required mattresses for foundation support in the depths of the Mississippi River. Bilhorn, Bower and Peters of St. Louis constructed the mattress out of willow trees, after which they skidded it into the river for Pier I from the west bank and sunk it to the riverbed on Friday, August 25, 1933. About 150 men drug long willow trunks to the riverbank and wove them into the 500-foot-wide mattress. (New Orleans Public Belt Railroad.)

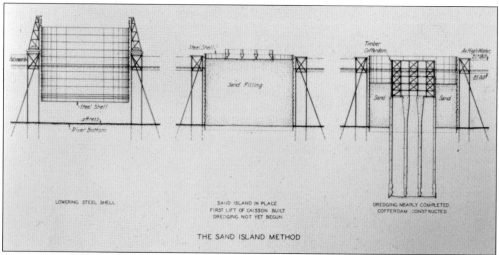

Contractors utilized the Sand Island Method to construct the piers in the river. The first step was to sink the willow mattress. The second step was to construct the falsework, followed by a steel shell within the falsework. Once the steel shell was complete, it was filled with sand, creating a "sand island." Next, workers constructed the first lift of the caisson, dredged sand out of the caisson, and continued the lift sequence as the bottoms deepened. Finally, a timber cofferdam was constructed on top of the caisson. (Library of Congress.)

The steel shell inside the timber falsework served as a container for the sand island. Pier III was near the center of the river, constructed to a depth of 169.4 feet below Mean Gulf Level. In the background, a crane lifts pieces into place while men place bolts into the steel members in the foreground. (New Orleans Public Belt Railroad.)

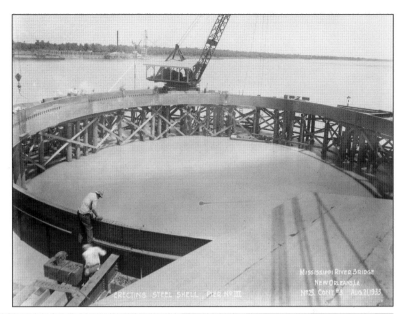

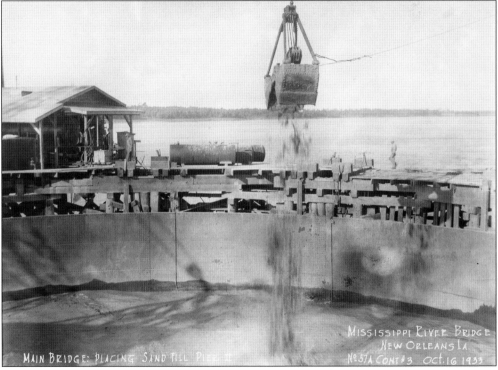

Contractor Siems-Helmers, Inc. of St. Paul, Minnesota, filled the steel shell with sand, creating the sand island for Pier II to a depth of 168.6 feet below Mean Gulf Level. Workers for Siems-Helmers, MacDonald Engineering, and McClintic-Marshall went on strike on Monday, July 17, 1933. The *New Orleans Times-Picayune* reported the strikers demanded pay increases, "common laborers, from 25 cents an hour to 40 cents; carpenters, 50 cents to 75 cents; engineers, 50 to 80 cents; piledrivers, 65 to 80 cents; and iron workers 65 cents an hour to $1.25." (New Orleans Public Belt Railroad.)

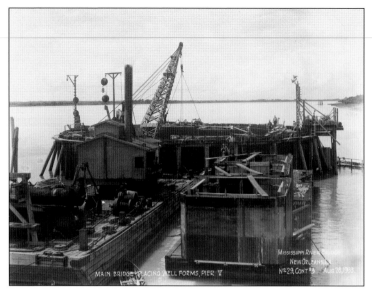

Pier V was the farthest east of the deep piers in the river. A crane stationed on a barge next to the pier location lifted and positioned the pieces of the construction forms. In this photograph, the timber falsework and steel shell are in place, and the contractor is placing the forms for the wells of the caisson. Additional forms can be seen on the barge adjacent to the crane barge. (New Orleans Public Belt Railroad.)

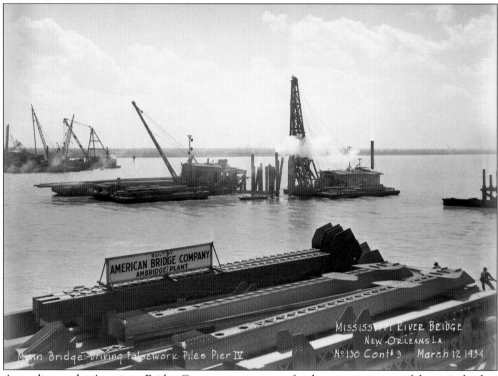

According to the American Bridge Company, contractor for the superstructure of the main bridge, it fabricated and erected a 1,850-foot cantilevered truss over the Mississippi River. The three-span cantilever unit consisted of two 529-foot anchor arms and a 790-foot main span consisting of two 145-foot cantilever arms and a 500-foot suspended span. The truss was constructed by the balanced cantilever method, work progressing in both directions from both piers. An additional 528-foot simple, through truss span flanked the New Orleans side of the main cantilever unit. The American Bridge Company constructed this simple span by cantilevering via a temporary tie to the cantilever unit. (New Orleans Public Belt Railroad.)

Workers place forms to pour concrete for the cutting edge of the caisson. This is the first step for caisson construction. The tapered edge of the caisson helped it sink, and cells in the caisson allowed for dredging of soil within and below the structure to get it to the desired depth under the river. (New Orleans Public Belt Railroad.)

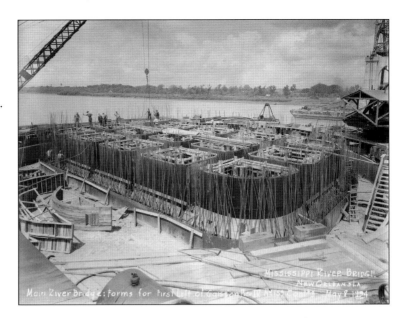

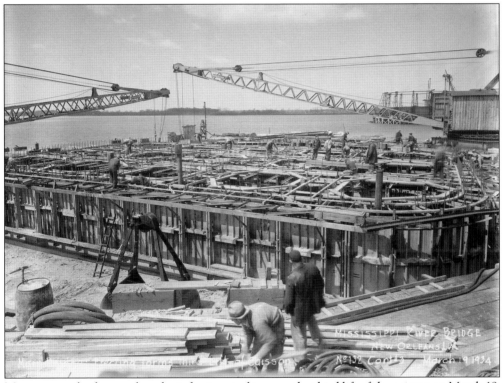

Men prepare the formwork and reinforcing steel to pour the third lift of the caisson on March 19, 1934. Siems-Helmers, Inc., the lowest bidder, proposed the Sand Island Method for constructing and installing caissons. The second-lowest bidder, the Dravo Contracting Company, had proposed a method in which air pressure could be used to control the sinking and stability of the caisson. A similar plan was later used for the foundations for the San Francisco–Oakland Bay Bridge. (New Orleans Public Belt Railroad.)

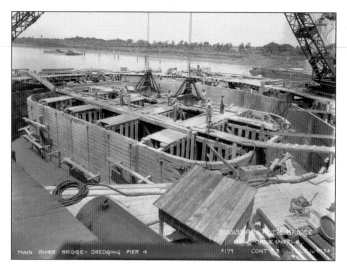

During caisson construction, workers dredged the sand island, followed by the river bottom, from within the caisson wells. The crane held clamshell-type buckets that dredge operators lowered in the open position. Once buckets were inside the excavation area, operators closed the clamshell in the soil so that the soil would remain in the bucket as they withdrew it. Work continued on the caissons 24 hours a day. (New Orleans Public Belt Railroad.)

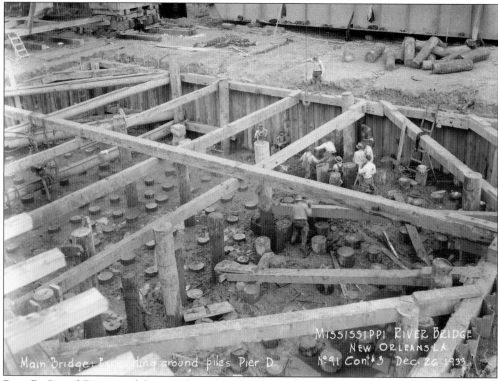

Piers B, C, and D required deep timber piles to support their loads. These piles for Pier D began at the ground surface at an elevation of approximately 12.5 feet, and ended at an average depth of -70.6 feet. Working the day after Christmas in 1933, contractors excavate around and trim piles to install the pile cap footing. Reinforcing steel tied the concrete footing into the concrete pier. (New Orleans Public Belt Railroad.)

On January 22, 1934, the contractor erected the timber cofferdam on top of the concrete caisson for Pier III. The wells of the caisson had been filled with water. These wells were not only used for dredging soils, but, once filled with water, they helped reduce the water pressure on the walls of the caisson. The holes in the wall of the caisson are jetting wells. (New Orleans Public Belt Railroad.)

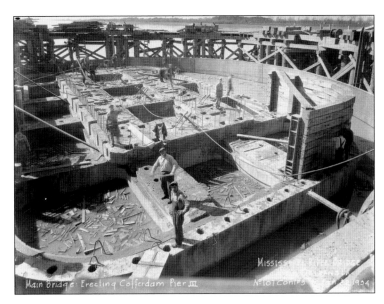

Main Bridge: Erecting Cofferdam Pier III

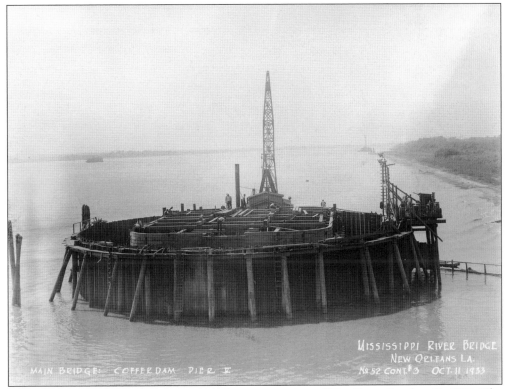

MISSISSIPPI RIVER BRIDGE
NEW ORLEANS LA.
MAIN BRIDGE: COFFERDAM PIER V N° 52 CONT #3 OCT. 11 1933

This photograph shows the progress on the construction of Pier V on October 11, 1933. The timber cofferdam is being constructed on top of the caisson within the steel shell. Prior to this point, after the caisson had reached the required depth, concrete was poured at the bottom of the caisson as a base seal. After the construction of the cofferdam, contractors poured the pedestal block for the pier, allowing the timber cofferdam to remain in the concrete. Workers trimmed the timber after the concrete cured. (New Orleans Public Belt Railroad.)

These photographs, likely taken in late 1933, show an aerial and a panoramic view of the main bridge piers under construction, looking downstream. The west bank is on the right side of the images. The caisson for each pier is at a different stage of construction: the steel shell is being built for Pier I, concrete lifts are being poured for the caisson for Pier II, forms for the wells of

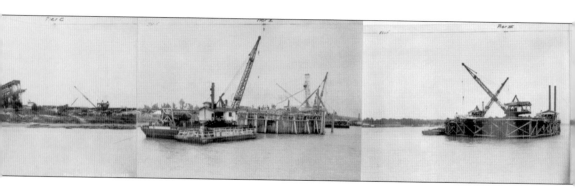

the caisson are being placed for Pier III, and the cofferdam is being erected for Pier V. Work on Pier IV had not started. Multiple crews worked around the clock to complete the caissons. (Both, Library of Congress.)

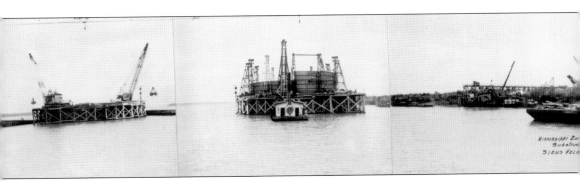

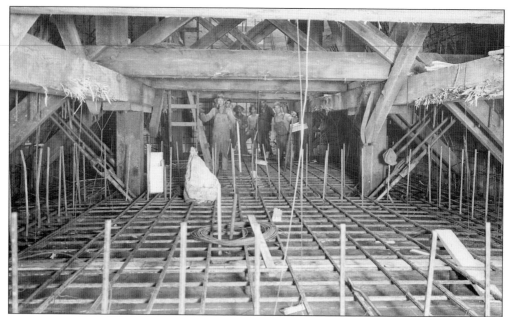

Shown here on November 20, 1933, is the top of the caisson for Pier V. The caisson was at an elevation of 35 feet below Mean Gulf Level, the design elevation from the plans. When men worked at depths below the water surface, where pressures were higher than at ground level, caisson disease, also called the bends, was a major concern. Learning from bridges constructed before the Huey P. Long Bridge, workers were more aware of the causes of the disease and limited their time working deep in the caisson. (New Orleans Public Belt Railroad.)

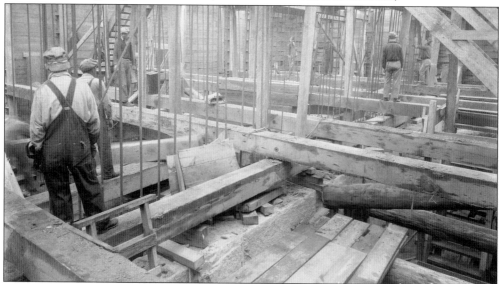

After removing the sand island, men rebraced the cofferdam in Pier III. Per the 1941 *Final Report*, contractors removed the sand island while the concrete seal was hardening at the bottom of the caisson. They dredged the remaining sand to the level of the normal riverbed and covered the area between the shell and the caisson with three feet of riprap stones. Divers unbolted the shell at the lowest connection above the riverbed, and cranes raised the shell for salvage. (New Orleans Public Belt Railroad.)

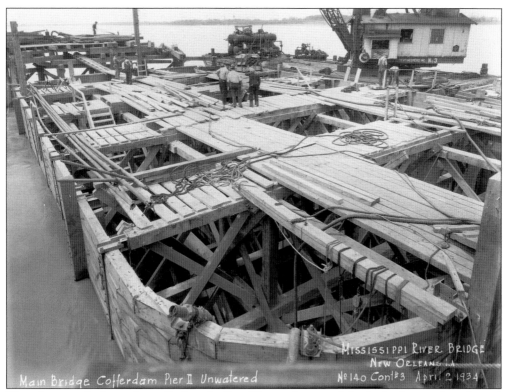

This photograph shows the cofferdam for Pier II being dewatered. In the background, tanks and a crane are visible. According to the 1941 *Final Report* by Frank Masters, "a steam boiler plant equipped with two large locomotive boilers, fuel oil storage tanks, water pumps, air compressor and a small generator set for electric lighting was erected on one corner of the completed falsework. Upon each of the other two corners, diagonally opposite each other, there was placed a large modern air-controlled whirler derrick with a 100-foot boom and an effective range of more than half of the enclosed circle." (New Orleans Public Belt Railroad.)

Left of center in this photograph, a man assists a diver into the water during the replacement of the cofferdam on Pier IV. Dewatering hoses can be seen covering the decks of the cofferdam. The diver was likely checking the concrete seal at the bottom of the caisson, 170 feet below the water surface. (New Orleans Public Belt Railroad.)

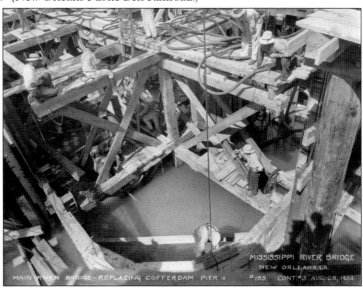

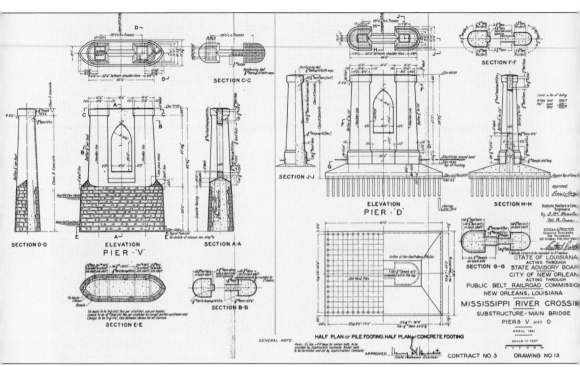

This portion of a plan sheet, with an original date of April 1931 and a revision date of March 1936, shows the details of Pier III. The plan, by Modjeski, Masters, & Case, shows all of the dimensions and details that would have been required for the contractor to build the bridge as Ralph Modjeski designed it. (Library of Congress.)

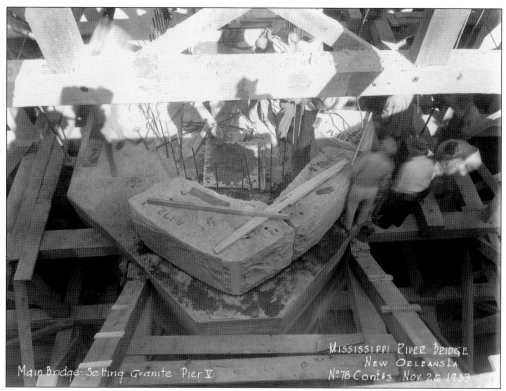

Main Bridge: Setting Granite Pier V

MISSISSIPPI RIVER BRIDGE
NEW ORLEANS LA.
N°78 Cont$3 Nov. 28 1933

According to the *New Orleans Times-Picayune*, the granite for the piers of the bridge was "the famous Stone Mountain granite" from Georgia. Granite quarrying started at Stone Mountain in the 1830s, and, over the years, this granite was used in many buildings and structures, including the locks of the Panama Canal, the steps to the East Wing of the Capitol, and the Imperial Hotel in Tokyo. The immense size of the blocks of granite can be seen in comparison to the men installing them. The granite facing was approximately 30 feet high and filled with concrete reinforced with steel rebar. The contractor strung lights around the construction area to prolong the time work could be done in the short daylight hours in December. (Both, New Orleans Public Belt Railroad.)

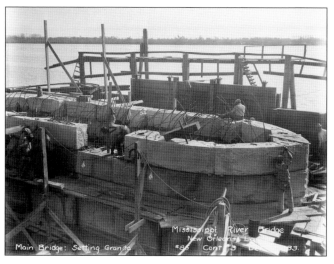

Main Bridge: Setting Granite

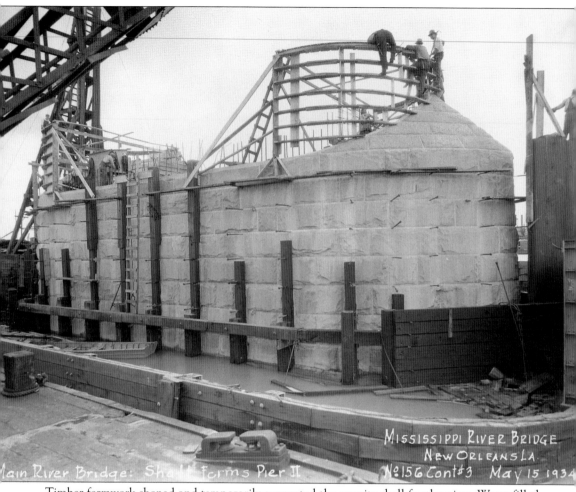

MISSISSIPPI RIVER BRIDGE
NEW ORLEANS LA.
№ 156 Cont #3 May 15 1934

Main River Bridge: Shaft forms Pier II

Timber formwork shaped and temporarily supported the granite shell for the piers. Water filled the cofferdam and surrounded the pier at this point in the construction because the work below the average water level of the river was complete. (New Orleans Public Belt Railroad.)

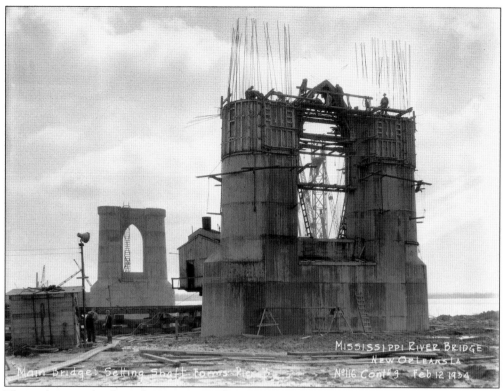

These photographs show the progress made on Pier B in 14 days, between February 12 (above) and 26 (below), 1934. Contractors mixed the concrete for the piers in a floating plant, which, according to the 1941 *Final Report*, was "of the most modern type, with the latest electric and automatic mechanisms for weighing, batching and measuring the materials." It could produce 120 cubic yards of concrete per hour. Two large oil-burning locomotive boilers supplied the steam power. A handling machine unloaded cement from barges moored alongside the floating plant into a supply bin. A clamshell bucket unloaded sand and gravel from the barges into mixing bins. The Mississippi River supplied the water for the concrete mix. Mixed concrete hoisted to the top of a 120-foot steel tower flowed by gravity to the forms through rubber-lined chutes. (Both, New Orleans Public Belt Railroad.)

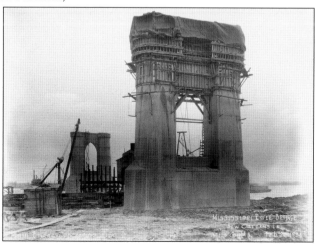

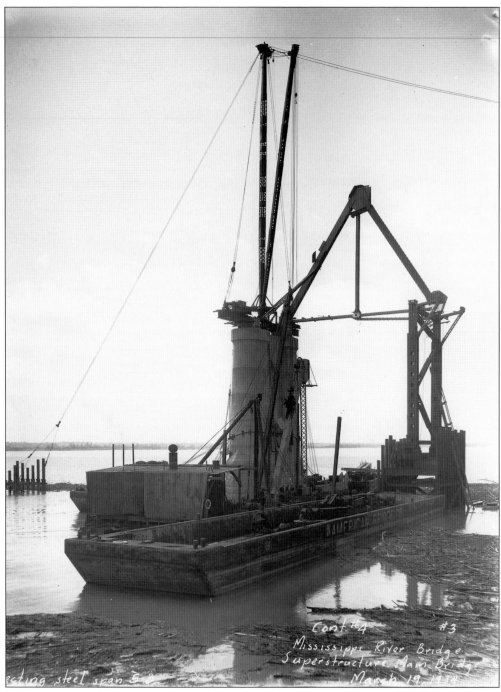

The handwritten text on the photograph reads:

Cont #4 #3
Mississippi River Bridge
Superstructure Main Bridge
March 19, 1934

Erecting steel span 5-8

The contract for the construction of the main bridge superstructure was signed on December 30, 1932, with the American Bridge Company. According to the 1941 *Final Report*, shipment of materials from the mill started in March 1933 and fabrication started in August 1933. This photograph shows the first erected span on March 19, 1934. Contractors installed temporary steel supports, or falsework, at critical points along the span to support the steel members until the installation of rivets connected the individual sections. (New Orleans Public Belt Railroad.)

Work started at Pier V and proceeded toward Pier D. Barges moved materials and cranes throughout the work areas. The erection derrick picked up pieces of steel and positioned them on the bridge. This photograph, from April 2, 1934, shows the progress on the same span as seen in the previous photograph over a two-week period. (New Orleans Public Belt Railroad.)

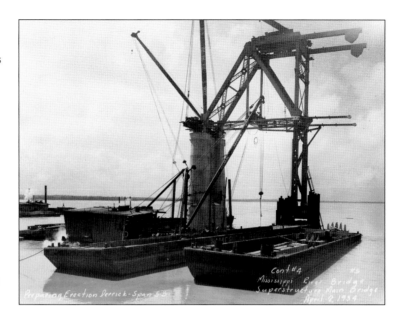

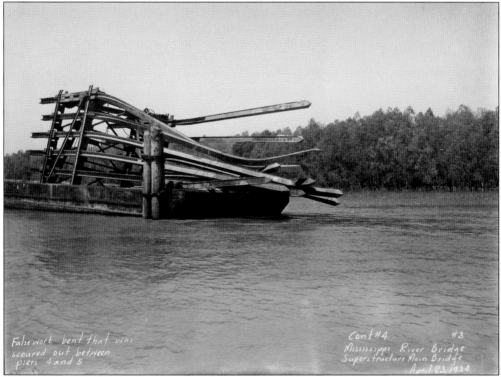

The immense force of the Mississippi River scoured and bent this piece of falsework, which had been located between Piers IV and V. The high flow rate of the river posed a significant challenge to construction. The *New Orleans Times-Picayune* noted that, "until recently engineers considered it impossible to construct a bridge across the river so near its mouth because of the river's depth and the swiftness of the current, which at times is more than six miles an hour." (New Orleans Public Belt Railroad.)

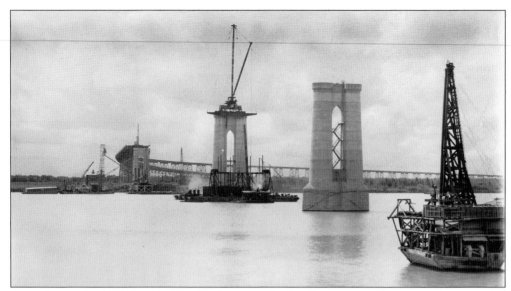

According to the 1941 *Final Report*, the American Bridge Company used guy derricks positioned on top of the piers. "These derricks, having as large as a 113-foot 6-inch mast and 95-foot boom, had the tops for their masts guyed by front and rear lines to adjoining piers. The heavy gasoline engines operating the hoisting lines to the derricks were mounted on barges moored to the piers, so that the erection loads of the derricks on the structure were unusually light." The derricks could be moved on the stringers of the railway floor, erecting truss members ahead of them and turning around to fill in the other members behind them. (New Orleans Public Belt Railroad.)

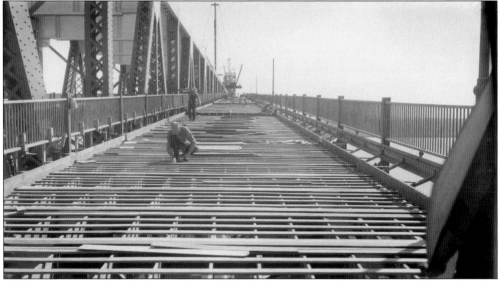

Workers erect forms for the highway lanes of the bridge that would later carry two lanes of traffic in a narrow, 18-foot-wide roadway with no shoulders. While the narrow lanes easily accommodated vehicles in the mid-1900s, by the end of the century, the lanes were narrower than Louisiana Department of Transportation and Development standards. American Bridge sublet the work of placing the concrete paving for the bridge highways to the W. Horace Williams Company of New Orleans, which also placed the roadways on the approaches. (New Orleans Public Belt Railroad.)

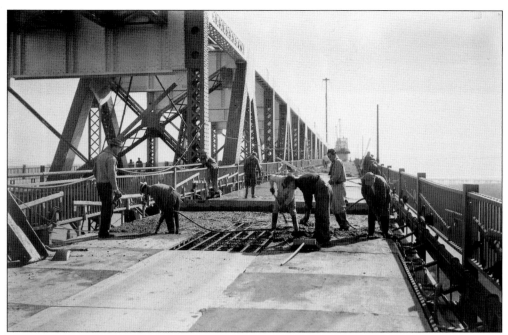

Though the main structure of the bridge was not yet complete when this photograph was taken on December 4, 1934, crews are placing concrete on the partially completed highway lanes that flanked the bridge. Two plants mixed concrete for the main bridge roadways, one under each approach structure near the levee. Wooden panels provided the men a place to walk over the cage of steel reinforcement. Freshly laid and smoothed concrete is evident in the background. (New Orleans Public Belt Railroad.)

On February 4, 1935, ten months before the opening of the bridge, contractors erect steel at Pier I near the west bank. In order to reduce the weight of the bridge and make the structure as economical as possible, the design of the metalwork specified special high-strength steels. Later, in the spring of 1935, Mississippi River high water events delayed construction because workers could not remove the falsework from the bridge. (New Orleans Public Belt Railroad.)

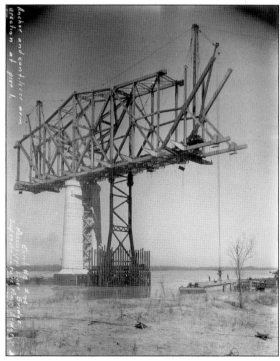

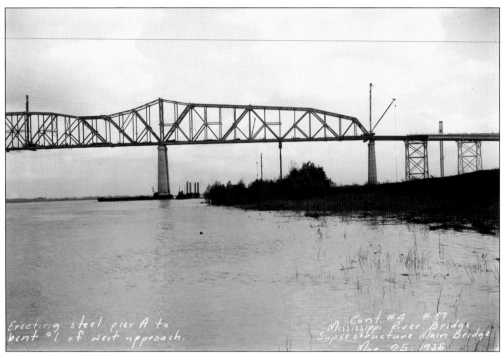

Erecting steel pier A to
bent #1 of west approach.

Cont #4 #87
Mississippi River Bridge
Superstructure Main Bridge
Mar. 25, 1935

On March 25, 1935, the contractor connected the steel in the main bridge to the west approach. As the structure rose, the American Bridge Company painted it with two coats of paint. Because the bridge was so heavy on the compressible soils, engineers designed it to allow some settlement, even some differential settlement, meaning one pier may move more than another pier. (New Orleans Public Belt Railroad.)

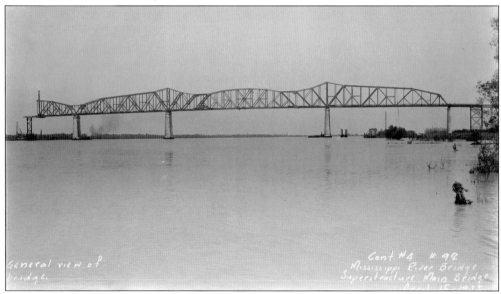

General view of
bridge.

Cont #4 #92
Mississippi River Bridge
Superstructure Main Bridge

In order to save money on insurance, contractors added fire protection to the timber railway deck. They covered exposed surfaces of the ties with a galvanized steel plate and added fire break plates between some ties. Additionally, fire extinguishers and emergency telephones were placed along the railway deck. (New Orleans Public Belt Railroad.)

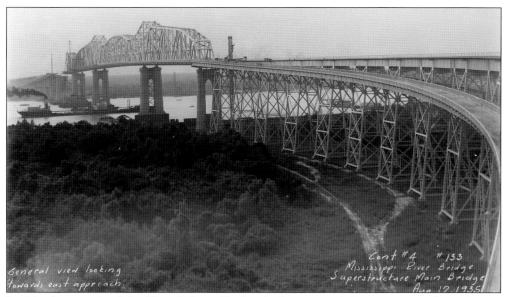

In this photograph of the Huey P. Long Bridge, looking toward the east approach on August 2, 1935, a ship passes beneath the bridge in the widest and deepest location. Two months later, contractors erected the final section of deck span. The State of Louisiana pushed for contractors to complete work on the final span, because the date of the bridge opening was already set and celebrations planned. (New Orleans Public Belt Railroad.)

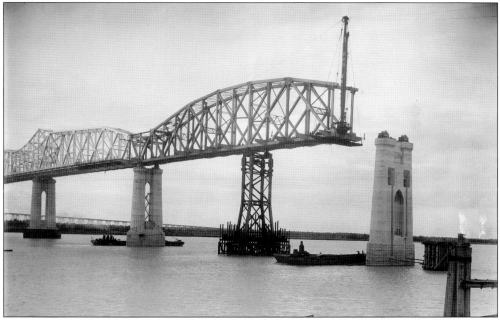

On September 9, 1935, the American Bridge Company erected the 528-foot simple span near the east bank of the river. The previous day, Sen. Huey P. Long was shot in the state capitol building in Baton Rouge. He died two days later. Long never lived to see the completion of his namesake bridge over the Mississippi River. After his death, his widow, Rose, was appointed to fill his seat in the Senate and later was elected to the position, making her the second woman elected to the US Senate, following Hattie Caraway of Arkansas. (New Orleans Public Belt Railroad.)

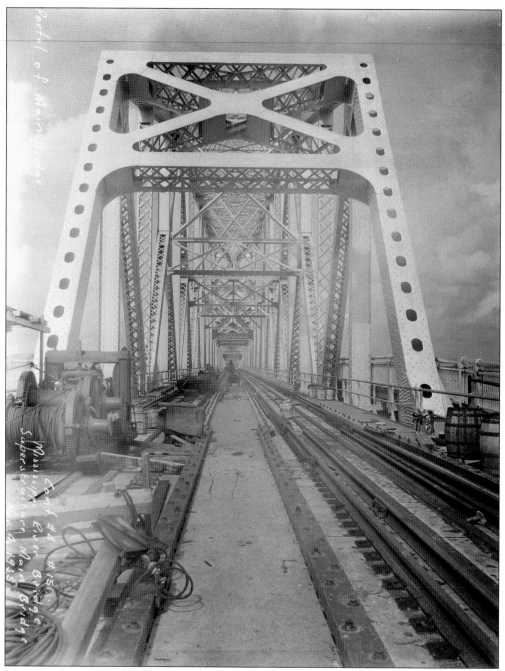

This is a view of the portal of the main bridge on November 4, 1935, just over one month before the bridge opened. At the opening ceremony and dedication of the $13 million structure on December 16, 1935, Gov. O.K. Allen stated that all credit for the construction of the bridge should go to the late senator Huey P. Long. (New Orleans Public Belt Railroad.)

Four

HUEY P. LONG
BRIDGE CELEBRATIONS

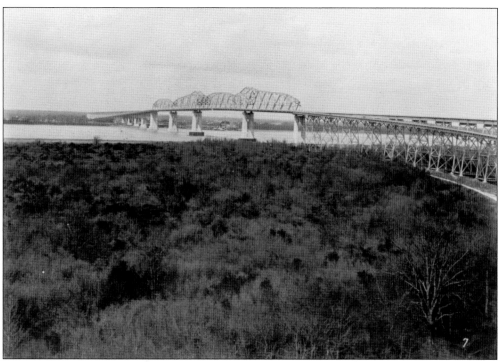

The completed Mississippi River Bridge at New Orleans, Louisiana, was a major engineering achievement in its design and construction. Rising above the undeveloped batture lands in 1935, it appeared as though it were a "bridge to nowhere" in a vast, swampy land. However, commercial and industrial development soon followed its completion, just as its main proponent, Gov. Huey P. Long, promised it would. (Library of Congress.)

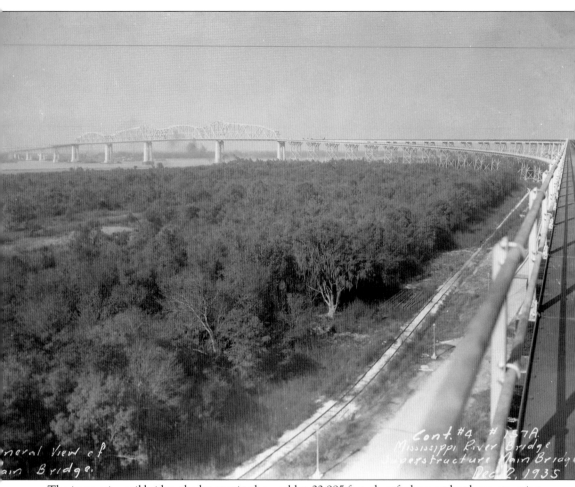

The impressive rail bridge, the longest in the world at 22,995 feet, dwarfs the west bank construction rail tracks that supported its creation. The total construction cost of the bridge was $9,424,981, more than $3 million under its $13 million budget. Governor Long pledged $7 million from the state for the highway and pedestrian portions of the bridge. (New Orleans Public Belt Railroad.)

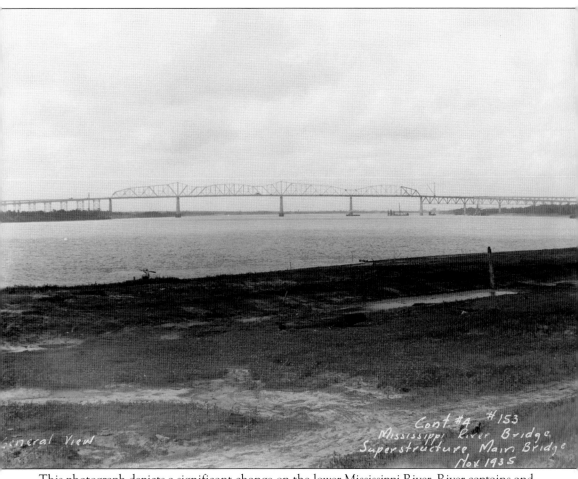

General View

Cont. #4 #153
Mississippi River Bridge
Superstructure Main Bridge
Nov. 1935

This photograph depicts a significant change on the lower Mississippi River. River captains and pilots now had to navigate under a bridge as they transported goods to and from the Port of New Orleans. The US War Department required a navigational opening across the deepest section, the thalweg, of the river channel. The thalweg in this reach of the river is not in the middle of the channel, but closer to its west bank, resulting in the asymmetrical shape of the bridge. (New Orleans Public Belt Railroad.)

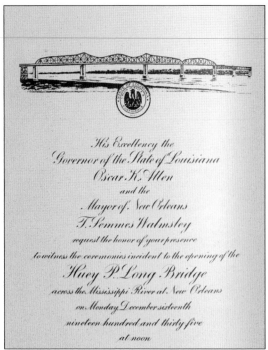

His Excellency the
Governor of the State of Louisiana
Oscar K. Allen
and the
Mayor of New Orleans
T. Semmes Walmsley
request the honor of your presence
to witness the ceremonies incident to the opening of the
Huey P. Long Bridge
across the Mississippi River at New Orleans
on Monday, December sixteenth
nineteen hundred and thirty-five
at noon

On December 16, 1935, Louisiana governor Oscar K. Allen and New Orleans mayor T. Semmes Walmsley hosted the grand-opening ceremony of the renamed Huey P. Long Bridge. More than 1,200 people made the inaugural round-trip across the bridge on the official, 16-car passenger train of the Southern Pacific Lines. A pageant depicting the evolution of transportation at New Orleans from Bienville to modern times was a highlight of the official opening of the bridge. (Tulane University.)

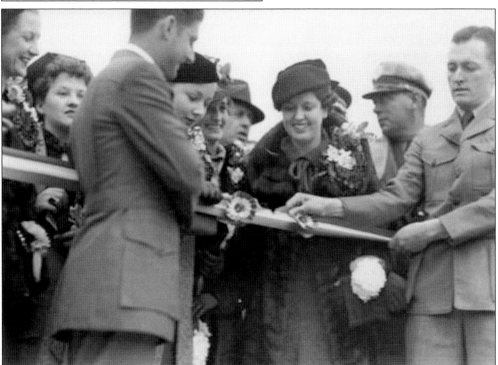

Governor Long was not present at the grand opening of his namesake bridge; an assassin killed him in the state capitol building on September 8, 1935. Rose Long, left, daughter of the late governor, had the honor of cutting the ribbon to open the highway sections of the bridge. (New Orleans Public Library.)

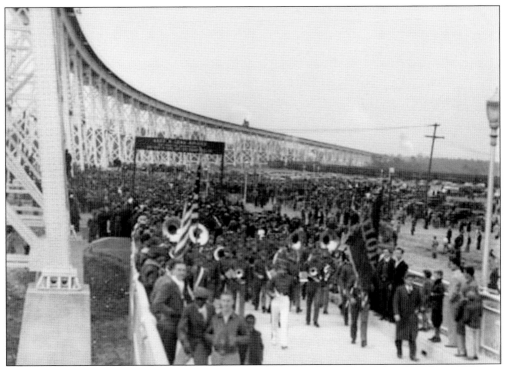

As part of the opening day celebration, a marching band leads a parade across the pedestrian bridge as a crowd of people surrounds the official sign designating the bridge as the Huey P. Long Bridge. Julius Dupont, president of the Old Spanish Trail Association of Louisiana, said, "East is West and West is East," in reference to the bridge now joining the eastern and western banks of the Mississippi River at New Orleans. (Louisiana TIMED Program.)

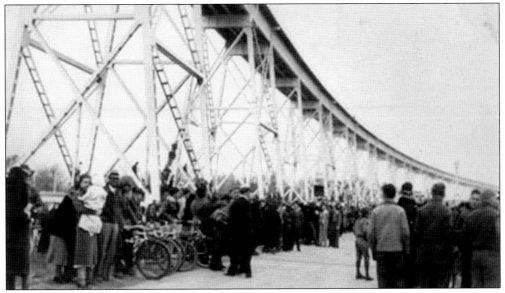

Bicyclists join the crowd to be among the first people to cross the new bridge. The New Orleans Bridge was the 29th bridge to span the Mississippi River, and the fifth trans-Mississippi structure built from plans designed by the Modjeski engineering firm. (Louisiana TIMED Program.)

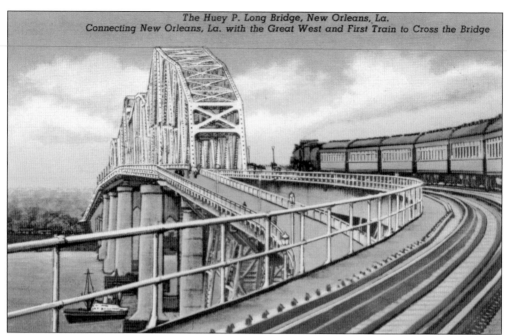

The Huey P. Long Bridge, New Orleans, La.
Connecting New Orleans, La. with the Great West and First Train to Cross the Bridge

The railroad approaches have a 1.25-percent grade. Engineers from the mountain section of the Southern Pacific rail system had to train local flat-country engineers on the intricacies of handling their locomotive and trains on this grade. (Authors' collection.)

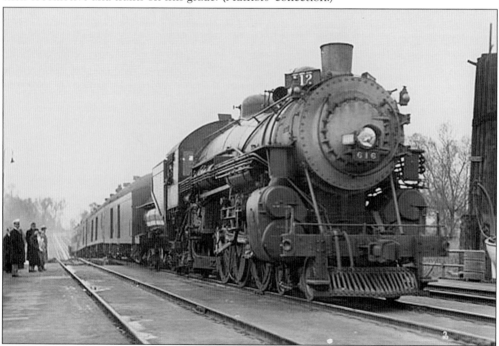

The first locomotive across the Huey P. Long Bridge was one of Southern Pacific's largest freight engines, piloted by Stanley L. Barras and Thomas G. Hebert, veterans of the Southern Pacific line. Regular train service on the bridge began on December 17 and continues today. (New Orleans Public Library.)

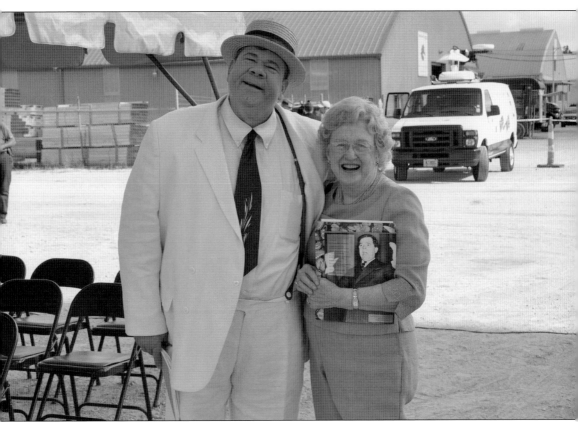

Spud McConnell as Huey Long stands with Nora Lambert, the granddaughter of the man who drove the first train across the Huey P. Long Bridge. As part of the dedication ceremony of the National Historic Civil Engineering Landmark plaque, Lambert and several members of Governor Long's family participated in the official unveiling. (Miles Bingham.)

New Orleans Public Belt Railroad officials and employees rode the rails in this specially fitted car en route to official ceremonies. The Public Belt continues to offer stylish rides on its rail line in a fully restored 1927 Pullman observation car it uses primarily for charitable functions. This automobile, named for Poland's greatest actress, Helena Modjeska, found a perfect fit in New Orleans. Modjeska was the mother of Ralph Modjeski, designer of the Huey P. Long Bridge. (New Orleans Public Library.)

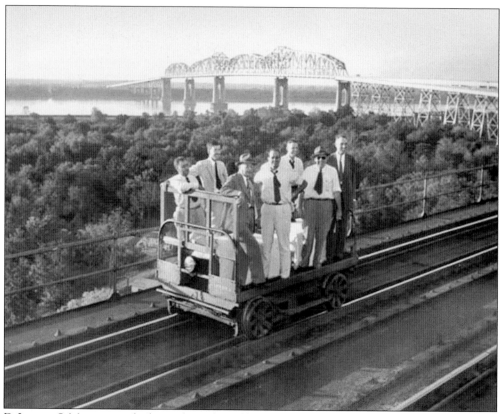

DeLesseps S. Morrison and others ride on the Public Belt's tracks with the Huey P in the background in this photo opportunity. Before becoming the mayor of New Orleans in 1946, Morrison was an attorney with the National Recovery Administration, a New Deal agency established by Franklin D. Roosevelt in 1933. The goal of the agency was to eliminate "cut-throat competition" by bringing industry, labor, and government together to create codes of "fair practices" and set prices. (New Orleans Public Library.)

Governor Long's first political position was in 1918 with the Louisiana Railroad Commission, a fitting start for the namesake of the first railroad bridge to cross the lower Mississippi River in Louisiana. The official bridge plaque dedicated at the grand-opening ceremony acknowledges people and agencies that made possible the construction of the Huey P. Long Bridge. In addition to governors Long and Allen, the Louisiana Highway Commission and the State Advisory Board included a who's who in Louisiana politics in the 1930s. (Library of Congress.)

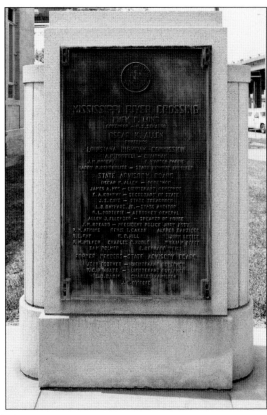

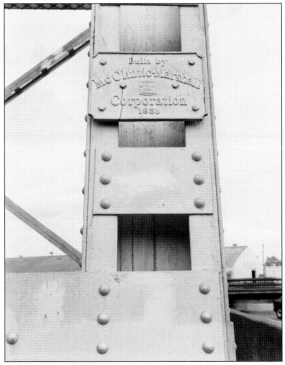

Every person and company involved in the construction of the bridge was justifiably proud to have played a role in its creation. The McClintic-Marshall Corporation installed a sign marking its involvement in building the Huey P at its start in 1933. In addition to San Francisco's Golden Gate Bridge, McClintic-Marshall built Detroit's Ambassador Bridge and New York City's George Washington Bridge. (Library of Congress.)

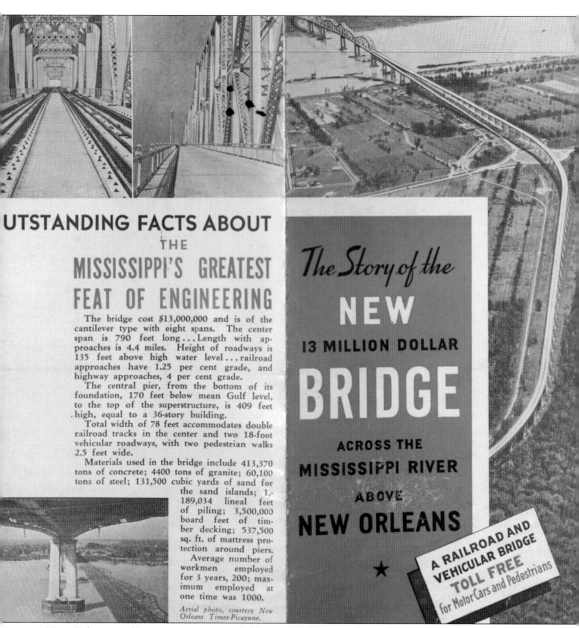

UTSTANDING FACTS ABOUT
THE
MISSISSIPPI'S GREATEST FEAT OF ENGINEERING

The bridge cost $13,000,000 and is of the cantilever type with eight spans. The center span is 790 feet long...Length with approaches is 4.4 miles. Height of roadways is 135 feet above high water level...railroad approaches have 1.25 per cent grade, and highway approaches, 4 per cent grade.

The central pier, from the bottom of its foundation, 170 feet below mean Gulf level, to the top of the superstructure, is 409 feet high, equal to a 36-story building.

Total width of 78 feet accommodates double railroad tracks in the center and two 18-foot vehicular roadways, with two pedestrian walks 2.5 feet wide.

Materials used in the bridge include 413,370 tons of concrete; 4400 tons of granite; 60,100 tons of steel; 131,500 cubic yards of sand for the sand islands; 1,189,034 lineal feet of piling; 3,500,000 board feet of timber decking; 537,500 sq. ft. of mattress protection around piers.

Average number of workmen employed for 3 years, 200; maximum employed at one time was 1000.

Aerial photo, courtesy New Orleans Times-Picayune.

The Story of the
NEW
13 MILLION DOLLAR
BRIDGE
ACROSS THE
MISSISSIPPI RIVER
ABOVE
NEW ORLEANS

★

A RAILROAD AND VEHICULAR BRIDGE
TOLL FREE
for Motor Cars and Pedestrians

New Orleans and Louisiana were justifiably proud of the new $13 million bridge ($218.5 million in 2012), calling it "the Mississippi's Greatest Feat of Engineering." Pamphlets extol its engineering features in eliminating "the last factor of isolation from a great metropolis founded 218 years ago in the midst of an 'impenetrable swamp.' " Not only did the bridge provide a connection for the goods entering and leaving the Port of New Orleans from the rest of the nation, but it also

THE MISSISSIPPI RIVER'S FINEST BRIDGE

December 16, 1935, goes down as an important date in New Orleans history. It marks the elimination of the last factor of isolation from a great metropolis founded 218 years ago in the midst of an "impenetrable swamp."

The new Mississippi river bridge gives New Orleans a continuous highway to the West. Gone are delays and inconvenience . . . traffic may now move unimpeded. Toll-free for vehicles and pedestrians, the great structure, which generations of thoughtful men said could not be built, forms a juncture just above New Orleans for United States Highway Number 90

29TH SPAN ACROSS THE "FATHER OF WATERS," SURPASSING ALL THE OTHERS IN SIZE, COST, AND AS A CO-OPERATIVE ACHIEVEMENT

. . . the Old Spanish Trail . . . from San Diego, California, to St. Augustine, Florida, and U. S. Numbers 61-65 . . . the Jefferson Highway . . . from New Orleans to Winnipeg, Canada.

A combination railroad and highway span, this bridge is characteristic of the indomitable spirit of the people of Louisiana, and is a symbol of their economic recovery.

The double railroad tracks will be used by the Southern Pacific Company to save at least an hour of precious time getting into and away from New Orleans, replacing the world's largest train ferry.

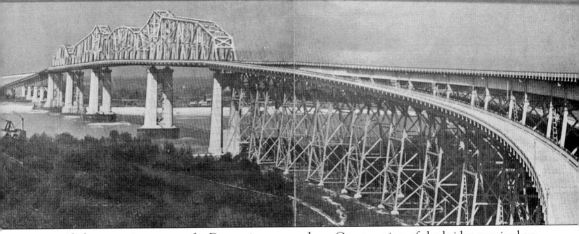

provided economic recovery for Depression-era workers. Construction of the bridge required an average of 200 workers for three years, with a maximum employment of 1,000 workmen. This was in addition to employment for steel, concrete, and timber manufacturers supplying materials used in the bridge's construction. The economic impact of the bridge continues to extend far beyond Louisiana, 78 years after its construction. (Both, Tulane University.)

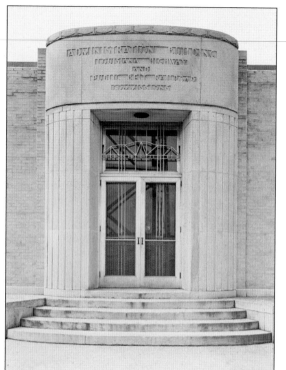

The Public Belt Railroad Commission and the City of New Orleans appointed a committee for the opening ceremonies and dedication on October 16, 1935. The committee was to "develop information relative to appropriate dedicatory services in connection with the official opening of the new bridge across the Mississippi River and to ascertain the relative cost of same." The committee had two months to plan and arrange the ceremony. Members of the committee included Edgar Murray (chairman), Jack Bloom, and C.S. Williams. The committee included the dedication of the administration building as part of its charge. Weiss, Dreyous & Seiferth designed the Administration Building of the Louisiana Highway and Public Belt Railroad Commission. R.P. Farnsworth & Company, Inc. erected the Art Deco office building in 1935 for the day-to-day operations and management of the bridge. (Both, Library of Congress.)

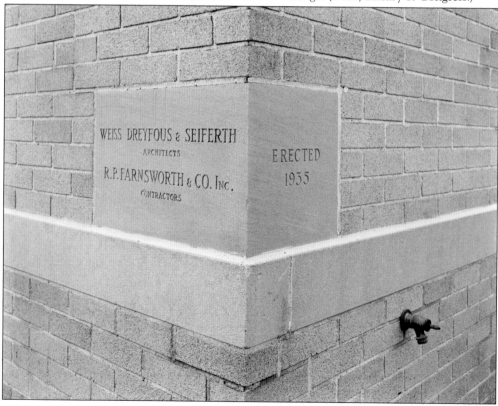

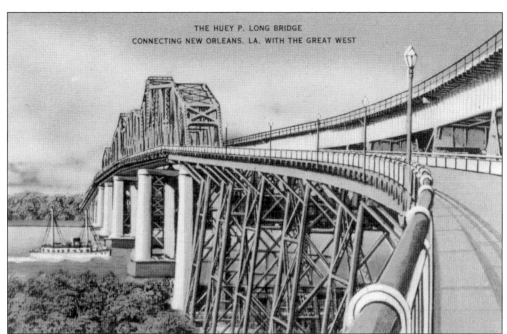

THE HUEY P. LONG BRIDGE
CONNECTING NEW ORLEANS, LA. WITH THE GREAT WEST

The bridge became a Louisiana tourist attraction. Pamphlets and postcards advertised it as one of the "greatest monuments conceived and built by the late U.S. Senator Huey P. Long." Long was charismatic and immensely popular for his programs and willingness to take forceful action, but his opponents accused him of dictatorial tendencies for his near-total control of the state government. The people of Louisiana, however, loved him. Long created a public works program for Louisiana that was unprecedented in the South, and the resulting roads, bridges, hospitals, schools, and state buildings have endured into the 21st century. During his four years as governor, Long increased paved highways in Louisiana from 331 miles to 2,301 miles, plus 2,816 miles of gravel roads. By 1936, the infrastructure program begun by Long had completed some 9,700 miles of new roads, doubling the size of the state's road system, and had built 111 bridges. He built a new governor's mansion and state capitol, at the time the tallest building in the South (at left, below). All of these projects provided thousands of much-needed jobs during the Great Depression, including 22,000, or 10 percent, of the nation's highway workers. (Both, authors' collection.)

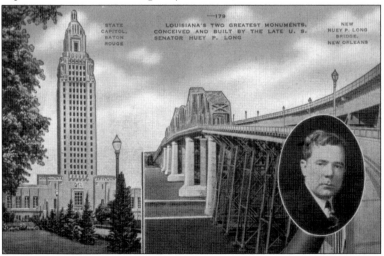

STATE CAPITOL, BATON ROUGE — LOUISIANA'S TWO GREATEST MONUMENTS, CONCEIVED AND BUILT BY THE LATE U. S. SENATOR HUEY P. LONG — NEW HUEY P. LONG BRIDGE, NEW ORLEANS

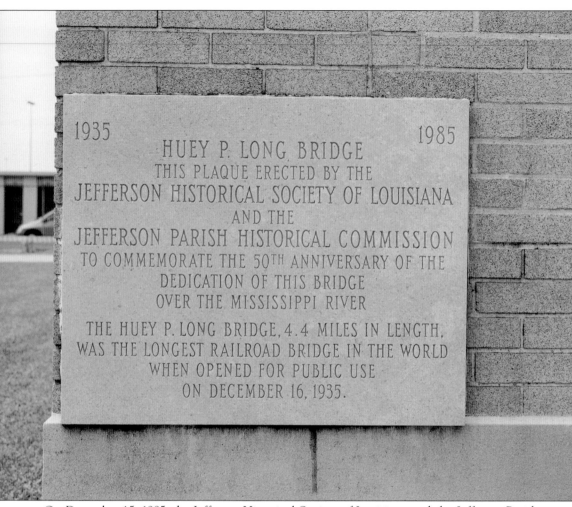

1935

1985

HUEY P. LONG BRIDGE
THIS PLAQUE ERECTED BY THE
JEFFERSON HISTORICAL SOCIETY OF LOUISIANA
AND THE
JEFFERSON PARISH HISTORICAL COMMISSION
TO COMMEMORATE THE 50TH ANNIVERSARY OF THE
DEDICATION OF THIS BRIDGE
OVER THE MISSISSIPPI RIVER

THE HUEY P. LONG BRIDGE, 4.4 MILES IN LENGTH,
WAS THE LONGEST RAILROAD BRIDGE IN THE WORLD
WHEN OPENED FOR PUBLIC USE
ON DECEMBER 16, 1935.

On December 15, 1985, the Jefferson Historical Society of Louisiana and the Jefferson Parish Historical Commission commemorated the 50th anniversary of the Huey P. Long Bridge. Louisiana state senator Francis E. "Hank" Lauricella, chairman of the Transportation, Highways, and Public Works Committee, was the master of ceremonies for a program that included a speech by William Conway, a partner at Modjeski & Masters who worked on the design and construction of the bridge in 1935. (Library of Congress.)

In 2012, the American Society of Civil Engineers, New Orleans Branch, hosted the dedication ceremony for the Huey P. Long Bridge as a National Historic Civil Engineering Landmark. Many local dignitaries spoke at the ceremony, including Jefferson Parish president John Young, Jefferson Parish council chairman Elton Lagasse, Representative Robert Billiot, New Orleans Public Belt general manager John Morrow, Louisiana Department of Transportation and Development secretary Sherri LeBlas, and Louisiana TIMED Managers program director Steve Spohrer. The invitation to the dedication ceremony honors the original invitation for the grand opening of the bridge. (Authors' collection.)

National ASCE President

Andrew W. Herrmann, P.E., SECB, F.ASCE

and

New Orleans ASCE Chapter President

Malay Ghose Hajra, Ph.D., P.E.

request the honor of your presence

to witness the ceremonies incident to the dedication of the

Huey P. Long Bridge

as an

American Society of Civil Engineers

National Historic Landmark

on Friday, September twenty-eighth

two thousand twelve

at ten thirty in the morning

River Road underneath the Huey P. Long Bridge

Sergio Perez, left, and Juan Lopez Jr. install the National Historic Civil Engineering Landmark plaque in preparation for the dedication ceremony on September 28, 2012. New Orleans Public Belt Railroad officials chose a location near the base of an approach pier that would allow visitors the opportunity to park their vehicles under the bridge for safe viewing of the plaque. Being cautiously optimistic, they also placed the plaque low enough to read, but high enough to discourage vandalism. (Louisiana TIMED Managers/Shane Peck.)

Respectful hands install the dedication plaque awarded by the American Society of Civil Engineers 80 years after construction began on the bridge. The planning committee for the dedication ceremony included Shane Peck, Bill Grass, Mike Neyman, and Tim Todd of LTM; Bambi Hall of Louisiana Department of Transportation and Development; Mike Dumas of New Orleans Public Belt Railroad; and Miles Bingham, Malay Ghose Hajra, and Tonja Koob Marking of ASCE. (Louisiana TIMED Managers/Shane Peck.)

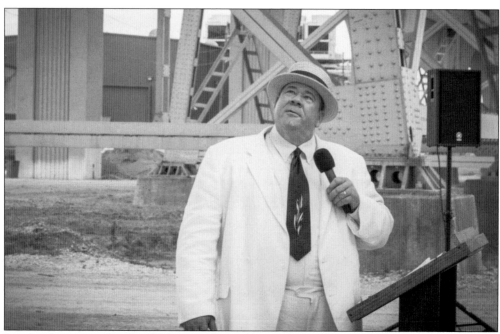

Local radio personality Spud McConnell, in character as Huey P. Long, emceed the National Historic Civil Engineering Landmark ceremony. Members of Governor Long's family were in the audience and joined the official unveiling of the ASCE plaque along with local dignitaries. (Miles Bingham.)

American Society of Civil Engineers national president Andrew W. Hermann, left, officially dedicates the Huey P. Long Bridge as a National Historic Civil Engineering Landmark as general manager John Morrow accepts the plaque on behalf of the New Orleans Public Belt Railroad. The Public Belt has been entrusted with maintaining the bridge since its completion in 1935. A continual maintenance force of 20 to 48 people has domiciled at the bridge for the past 78 years, replacing ties and rivets and cleaning and painting the surface. Maintenance is funded by the Public Belt, tenant rail lines, and the Louisiana Department of Transportation and Development. (Miles Bingham.)

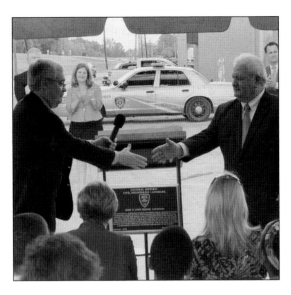

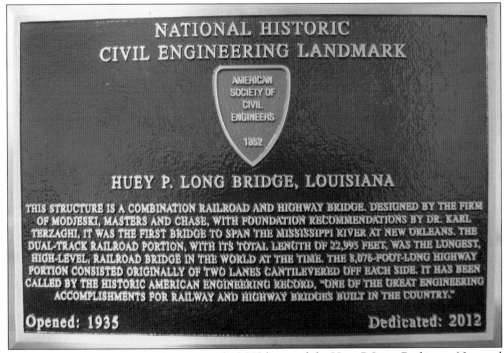

NATIONAL HISTORIC
CIVIL ENGINEERING LANDMARK

AMERICAN
SOCIETY OF
CIVIL
ENGINEERS

1852

HUEY P. LONG BRIDGE, LOUISIANA

THIS STRUCTURE IS A COMBINATION RAILROAD AND HIGHWAY BRIDGE. DESIGNED BY THE FIRM OF MODJESKI, MASTERS AND CHASE, WITH FOUNDATION RECOMMENDATIONS BY DR. KARL TERZAGHI, IT WAS THE FIRST BRIDGE TO SPAN THE MISSISSIPPI RIVER AT NEW ORLEANS. THE DUAL-TRACK RAILROAD PORTION, WITH ITS TOTAL LENGTH OF 22,995 FEET, WAS THE LONGEST, HIGH-LEVEL, RAILROAD BRIDGE IN THE WORLD AT THE TIME. THE 8,076-FOOT-LONG HIGHWAY PORTION CONSISTED ORIGINALLY OF TWO LANES CANTILEVERED OFF EACH SIDE. IT HAS BEEN CALLED BY THE HISTORIC AMERICAN ENGINEERING RECORD, "ONE OF THE GREAT ENGINEERING ACCOMPLISHMENTS FOR RAILWAY AND HIGHWAY BRIDGES BUILT IN THE COUNTRY."

Opened: 1935 Dedicated: 2012

The American Society of Civil Engineers (ASCE) honored the Huey P. Long Bridge as a National Historic Civil Engineering Landmark based on its age of more than 50 years; its national, historic, and civil engineering significance; its representation of a significant facet of civil engineering history; its civil engineering uniqueness; and its contribution to the development of the nation. ASCE has designated less than 300 such landmarks in the world, including the Eiffel Tower, the Panama Canal, and the Golden Gate Bridge. (Louisiana TIMED Program.)

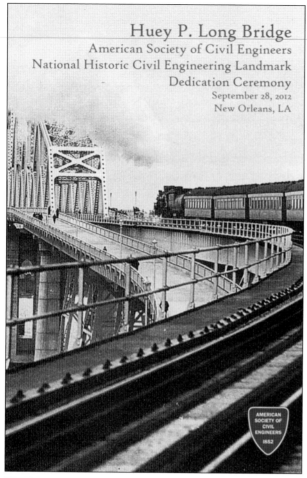

Huey P. Long Bridge
American Society of Civil Engineers
National Historic Civil Engineering Landmark
Dedication Ceremony
September 28, 2012
New Orleans, LA

To commemorate the landmark dedication, the planning committee produced a 20-page program detailing the history and engineering significance of the Huey P. Long Bridge and describing its future with the completion of the 2005–2013 widening project. As part of its effort to preserve the history of the bridge, the planning committee distributed archival copies of the program to state and university libraries for inclusion in their Louisiana collections, and provided copies to area elementary, junior high, and high school libraries. The committee also produced commemorative medallions, which it distributed to attendees of the ceremony. The medallions honor the inaugural train crossing from the December 16, 1935, opening ceremony. (Both, Louisiana TIMED Managers.)

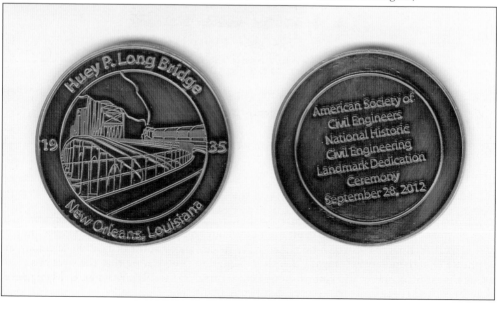

In preparation for the expansion of the vehicular traffic lanes, contractors removed tens of thousands of original rivets from steel members and plates in 2009. Deconstructing bridge sections revealed that contractors utilized at least three different types of rivets in the construction of the bridge. Widening contractors had to complete hazardous waste manifests to transport the rivets off of the job site due to remnants of lead paint adhered to the surfaces. (Library of Congress.)

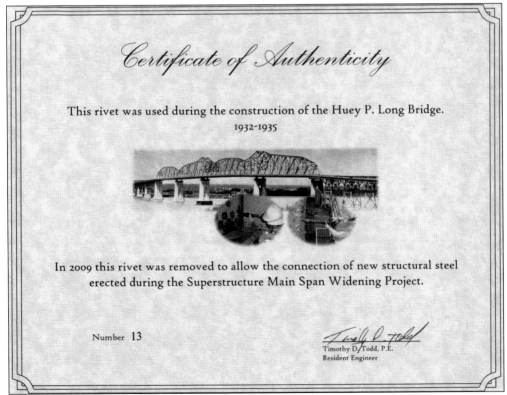

Certificate of Authenticity

This rivet was used during the construction of the Huey P. Long Bridge.
1932-1935

In 2009 this rivet was removed to allow the connection of new structural steel erected during the Superstructure Main Span Widening Project.

Number 13

Timothy D. Todd, P.E.
Resident Engineer

Mike Neyman, LTM engineer and dedication ceremony committee member, salvaged a limited edition of 21 original rivets, which he presented to special guests at the dedication ceremony. A certificate of authenticity accompanied each presentation rivet, stating that the rivet was used during the construction of the Huey P. Long Bridge from 1932 to 1935. Resident LTM engineer Timothy D. Todd personally signed each certificate. (Authors' collection.)

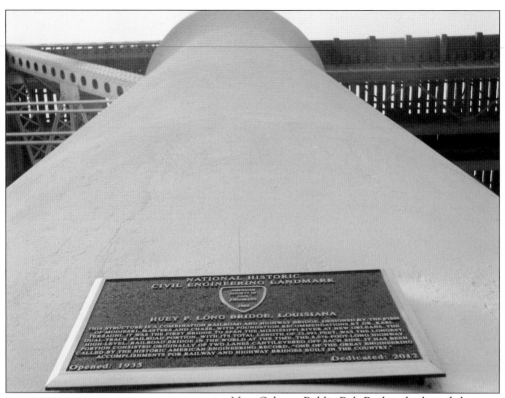

New Orleans Public Belt Railroad selected the bridge pier adjacent to River Road on the east bank for the permanent location of the ASCE plaque. This location offers visitors not only a view of the historic bridge and its dedication plaque, but also an excellent view of the widened traffic lanes built as part of the expansion project. In 2063, the Huey P. Long Bridge Widening Project will be eligible for designation as a National Historic Civil Engineering Landmark. (Louisiana TIMED Managers/Shane Peck.)

The American Society of Civil Engineers, New Orleans Branch, hosted the dedication ceremony on September 28, 2012. Pres. Malay Ghose Hajra, left, national ASCE president Andrew W. Herrmann, center, and Louisiana Section president Ronald Schumann were present to officially acknowledge the New Orleans Public Belt Railroad as the owner of the historic bridge. Louisiana Department of Transportation and Development secretary Sherri H. LaBas also received a landmark plaque for the State of Louisiana, courtesy of the Louisiana Transportation Infrastructure Model for Economic Development (TIMED) Program. (Miles Bingham.)

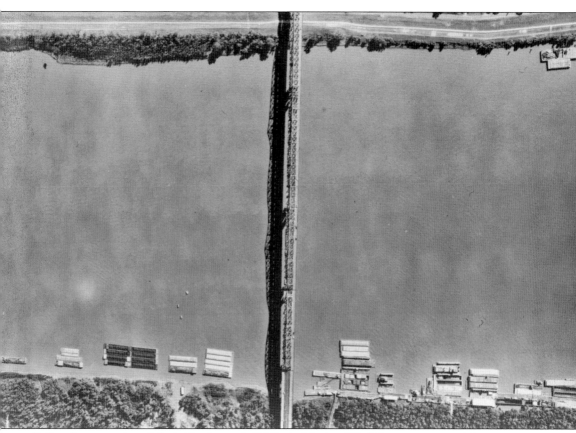

Before the expansion of the bridge began in 2005, the National Park Service preserved the existing Huey P. Long Bridge in a photographic record included in the Library of Congress. As seen in this aerial photograph of the bridge, river, rail, and road transportation developed on both sides of the Mississippi River as a result of the construction of the bridge. (Library of Congress.)

As part of the public outreach for the widening of the bridge, LTM held a "Last on the Lanes, First to the Future" drawing that attracted 1,853 entrants. Kathryn Aikman was randomly selected to be the last member of the public to take the final ride over the old lanes. Aikman took the final ride in a 1931 Model A Ford provided by Mike and Jimmy Lemoine of River Ridge on April 29, 2012. (Louisiana TIMED Managers.)

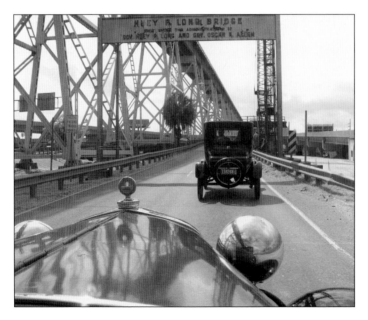

The original sign photographed in the grand opening ceremony was the site for the last vehicles to cross the old lanes of the bridge on April 29, 2012. The completed Huey P. Long Bridge Widening Project will include three 11-foot lanes in each direction featuring eight-foot outside and two-foot inside shoulders. The total width will more than double, from the current 18-foot-wide driving surface to a 43-foot-wide driving surface. (Louisiana TIMED Managers.)

Gaynell Peterson won the random drawing to be the first member of the public to ride on the new lanes. Peterson made the ride on April 28, 2012, in an American-made 2012 electric car provided by Bergeron Chrysler Dodge Jeep Ram. "I was reminded that my father was among the first people to drive across the old bridge when it opened. So, he would be very proud that I will be the first member of the public to cross the new bridge," Peterson said. (Louisiana TIMED Managers.)

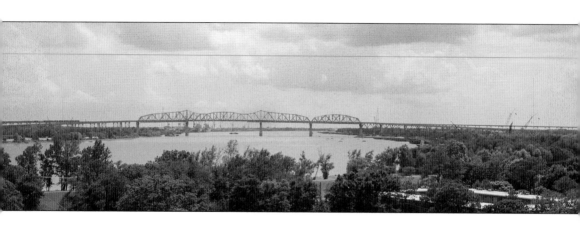

On May 10, 2012, the Huey P. Long Bridge was in the seventh year of its retrofit project. The benefits of the long-planned project include safety, emergency evacuation, economic development, connectivity, and quality of life. The *New Orleans Times-Picayune* reported, "More than 20 years in the making and scheduled for completion in 2011 [now 2013 due to delays resulting from Hurricanes Katrina, Rita, Gustav, Ike, and Isaac], the project will not only allow commuters to loosen their white-knuckled grips on their steering wheels but also, officials hope, further accelerate development of the West Bank, where Jefferson Parish's last tracts of vast green space sit ripe for growth." (Both, Louisiana TIMED Managers.)

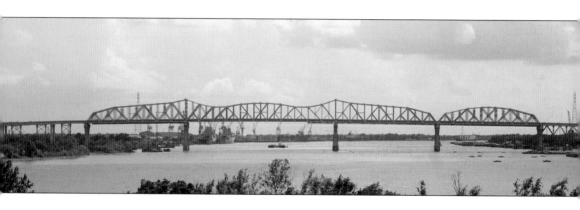

Five

HUEY P. LONG BRIDGE WIDENING PROJECT

The first 15 photographs of this chapter document the conditions of the Huey P. Long Bridge in 2005 as part of the Heritage Documentation Program of the National Park Service, Historic American Engineering Record, before the onset of the widening project. The captions describe the planning and initiation of the new project. Planners began discussions for widening the Huey P. Long Bridge in the 1980s, but funding was not established for the project until the creation of the Louisiana Transportation Infrastructure Model for Economic Development (TIMED) Program in the 1990s. The state selected the engineering firm of Modjeski & Masters, Inc., which designed the bridge, to design the expansion from two nine-foot-wide vehicular lanes to three 11-foot-wide lanes with shoulders. (Library of Congress.)

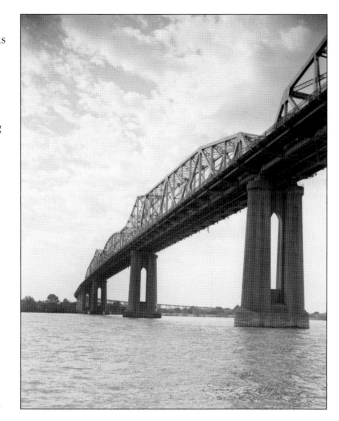

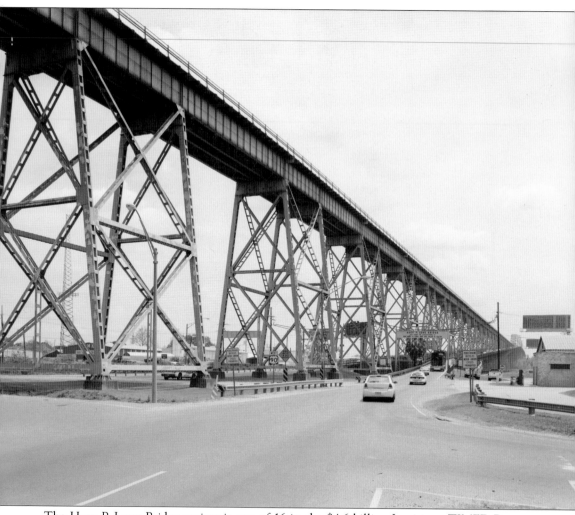

The Huey P. Long Bridge project is one of 16 in the $4.6 billion Louisiana TIMED Program managed by Louisiana TIMED Managers (LTM), a joint venture including GEC Inc., Parsons Brinckerhoff, and the LPA Group, Inc. A 4¢ gas tax initially funded the TIMED program. Bond sales followed to provide the funding for all 16 projects. (Library of Congress.)

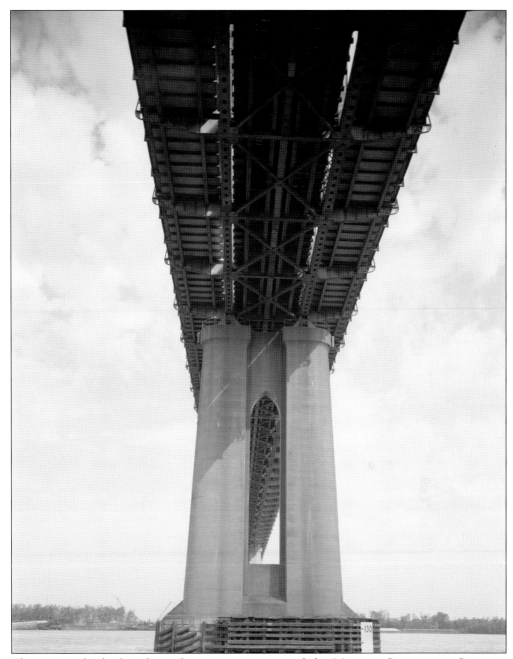

The contract for the first phase of construction was awarded to Massman Construction Company on February 14, 2006. Phase I of the widening project included widening and strengthening the bridge substructure. Work began on this contract in April 2006 with an official ground-breaking ceremony and finished at the end of May 2009. (Library of Congress.)

The contract for Phase II was awarded to Boh Brothers Construction Company of New Orleans on May 23, 2006. Phase II of the widening project included modifications of select railroad supports to facilitate new east bank and west bank bridge approaches. Work began on this contract in October 2006 and finished at the end of June 2008. (Library of Congress.)

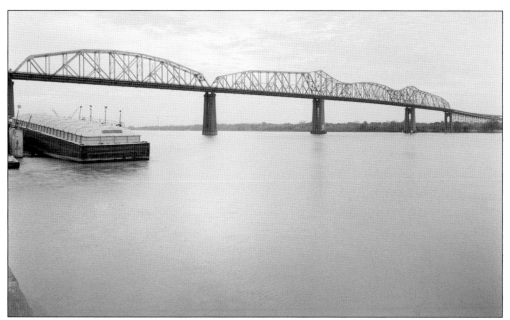

The contract for Phase III construction was awarded to Massman Construction Company, Traylor Brothers, Inc., and IHI, Inc. on August 17, 2007. Phase III of the project was widening of the existing truss of the main span of the bridge on each side to accommodate new travel lanes and shoulders. Work began on this contract in early 2008 and finished in July 2012. (Library of Congress.)

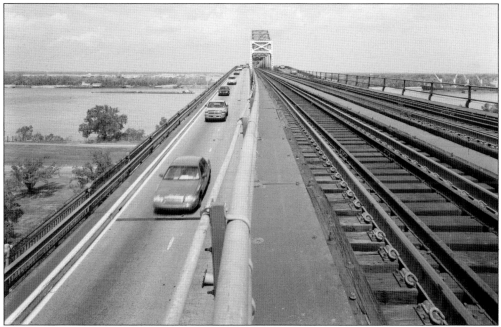

The contract for Phase IV construction was awarded to Peter Kiewit Sons', Inc., Massman Construction Company, and Traylor Brothers, Inc. in early 2008. Phase IV of the project included the construction of the new approaches to the bridge and widening of the existing nine-foot-wide travel lanes. Work began on this contract in June 2008 and is scheduled to be completed in the summer of 2013. (Library of Congress.)

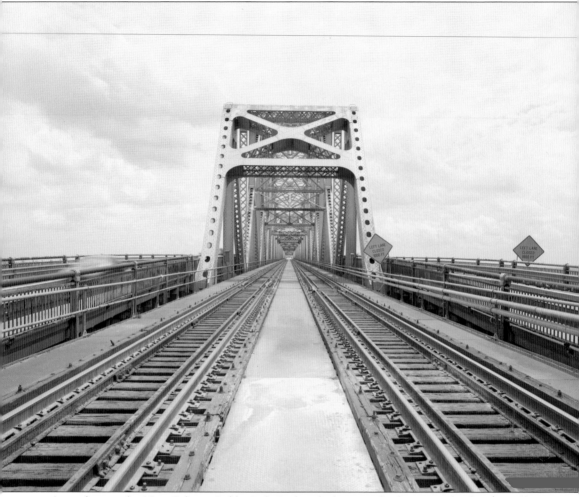

According to the New Orleans Public Belt Railroad, the main bridge was valued at $6 million ($100.6 million in present dollars) at the time of construction. Today, that same portion of the bridge is valued at $185 million. The $1.2 billion widening is the single largest transportation infrastructure project in Louisiana history. (Library of Congress.)

The Public Belt has maintained the bridge since its completion in 1935. Protection and upkeep are ongoing tasks on the four-and-a-half-mile steel bridge. Crew members maintain railroad ties, apply paint that protects steel members; and maintain navigational aids, fender systems on the piers, and the property in general. New Orleans Public Belt Railroad has consistently earned high marks for this infrastructure maintenance during the bridge's annual inspections. (Library of Congress.)

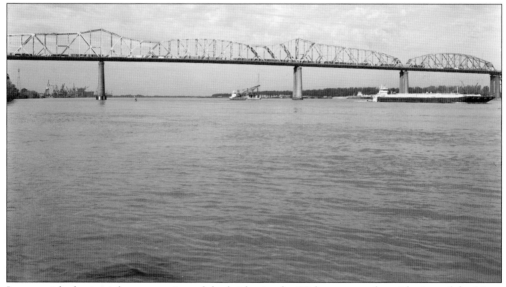

Just as with the initial construction of the bridge in the 20th century, the widening of the Huey P will bring more development opportunities to the west bank of Jefferson Parish by allowing smoother access from the east bank. *City Business* stated that the expansion would allow for business and population growth, especially in the undeveloped areas of the west bank near the bridge. (Library of Congress.)

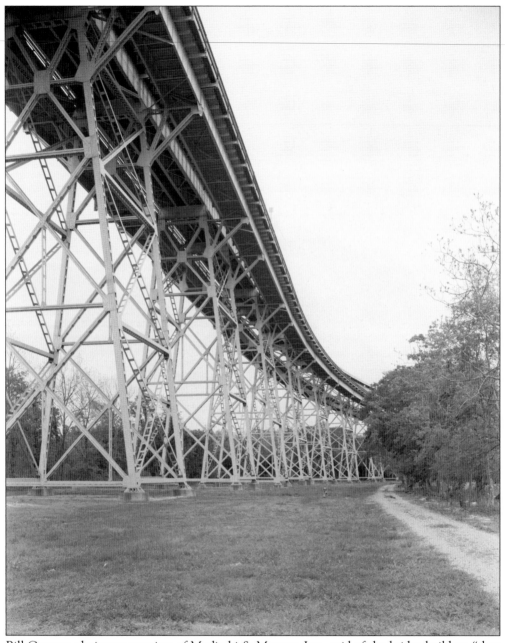

Bill Conway, chairman emeritus of Modjeski & Masters, Inc., said of the bridge builders, "they got it right. They were good engineers then . . . as good as we are today. They didn't have all the methods that we have, but they were as good as or better than we are in the understanding of what was going on and what needed to be calculated. I am still impressed by what they did." (Library of Congress.)

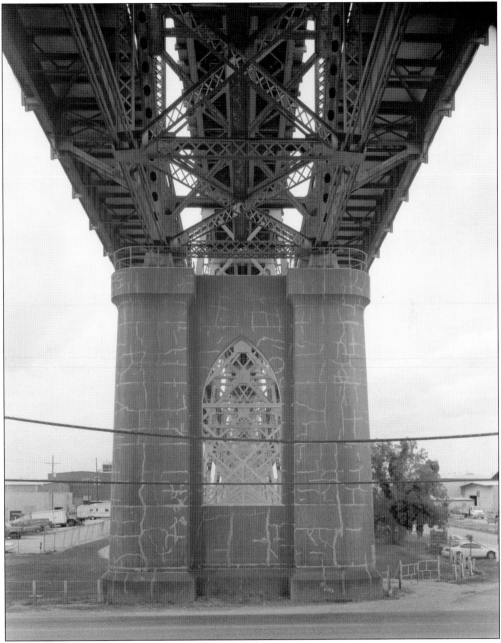

According to the Louisiana Department of Transportation and Development, 50,000 motorists crossed the Huey P. Long Bridge daily in 2004. From the beginning, part of the planning and design for the bridge expansion was to maintain open traffic lanes in both directions during a majority of the construction and have as few full traffic closures as possible. (Library of Congress.)

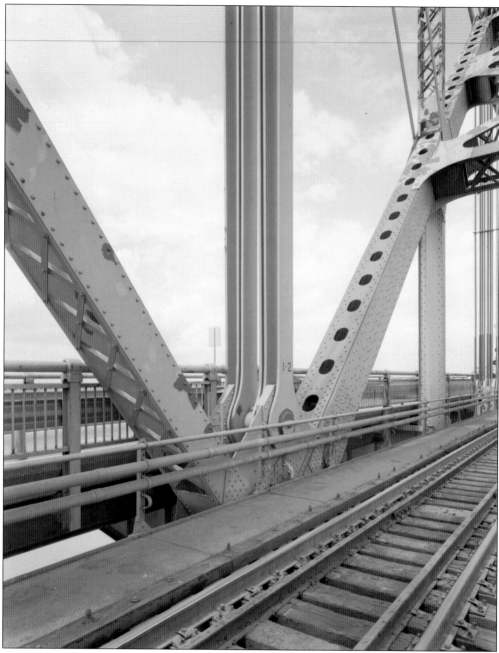

As an original requirement of the bridge bonds, Modjeski & Masters, Inc. has inspected the bridge annually since its completion. According to the Public Belt, the inspection program, designed almost 80 years ago and in place long before federal mandates for inspection, meets current infrastructure inspection standards. Modjeski & Masters, Inc. annually inspects one-third of the bridge in depth; the other two-thirds of the bridge receive a general inspection. Thus, over a three-year period, the engineering firm inspects the entire bridge in depth. The bridge has always earned "good condition" evaluations. (Library of Congress.)

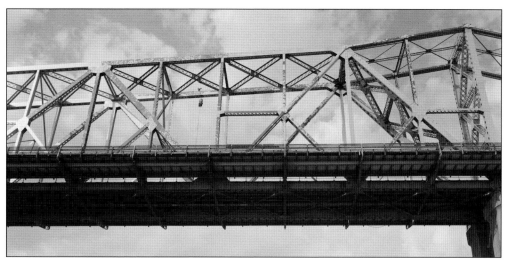

Part of the planning process involved an investigation into possible environmental impacts that the bridge expansion may have on humans, flora, fauna, air, water, and land. The environmental assessment compared various alternatives to the expansion of the bridge and investigated the effects of each alternative with regard to multiple environmental factors, including wetlands, threatened and endangered species, cultural resources, socioeconomics, and cost. Based on that analysis, the chosen alternative was to expand the existing bridge rather than construct a new one. (Library of Congress.)

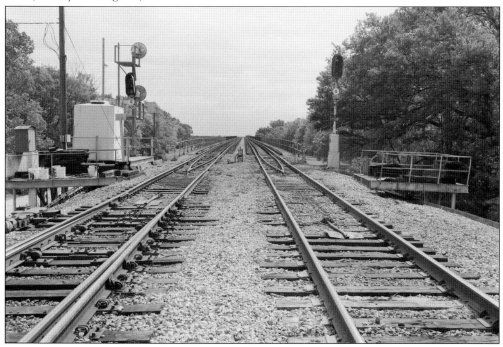

The existing bridge could easily support the increased load from the wider traffic lanes without modifications to the originally designed foundations. "This is a two-rail bridge, and one track of rail loading is equivalent to 12 lanes of automotive traffic," said Bill Conway of Modjeski & Masters, Inc. Although the foundations could support the additional weight, engineers had to add to the piers to support the big trusses needed to cantilever the new lanes. (Library of Congress.)

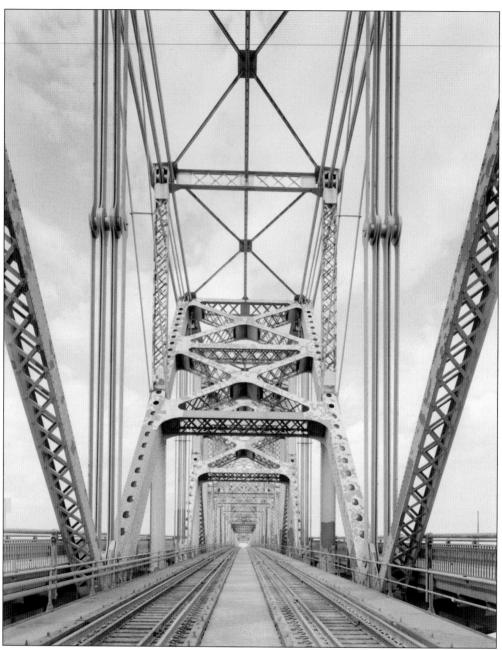

In August 2006, according to a TIMED press release, Louisiana legislators joined local leaders on a tour of the Huey P. Long Bridge Widening Project to see firsthand the progress and magnitude of the $660 million project. "The Huey P. Long Bridge Widening Project is vital to the recovery of the New Orleans area and DOTD [Department of Transportation and Development] wants to show the public, media and elected officials the progress and success of the project," said Cedric Grant, DOTD deputy secretary. "Hosting this tour allows us [DOTD] to keep local leaders involved and informed." (Library of Congress.)

At a ceremony on February 19, 2010, the American Concrete Institute, Louisiana Chapter, presented the Huey P. Long Bridge Widening Project with an Award of Excellence. The award was given in recognition of outstanding and innovative use of concrete products in the widening of the main piers. The work required an estimated 16,544 cubic yards of concrete, enough to fill five Olympic-sized pools. (Louisiana TIMED Managers.)

To expand the piers to hold the new highway lanes, the contractor used large barges to stage equipment in the Mississippi River. Workers utilized that equipment to build steel frames around the piers to support the additional concrete needed for the expansion. The extra concrete around the piers supported the steel pieces, which projected from the pier at an angle. (Louisiana TIMED Managers.)

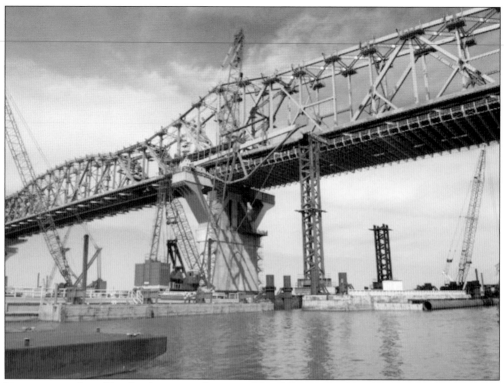

Literature produced by the American Society of Civil Engineers describes the expansion's steel work: "the contractor for the steel work was MTI—a joint venture of Massman Construction Co., Traylor Brothers, Inc., and IHI, Inc. MTI used innovative span-by-span construction on the structure. The process allowed them to build three of the spans on barges in the river and then lift them into place while limiting disruptions to river navigation, speeding up the work, and making it safer for workers. These monumental efforts became known as the 'Big Lifts.'" (Louisiana TIMED Managers.)

As part of the quality control plan for the steel work, inspectors verified that the materials, manufacturing, assemblages, and installations of every aspect of the widening project met design engineers' plans and specifications. The inspections occurred on the ground and suspended over the Mississippi River, depending on the phase of construction. As compared to personal protection equipment employed during the initial bridge construction, worker safety has come a long way in the past 80 years. (Louisiana TIMED Managers.)

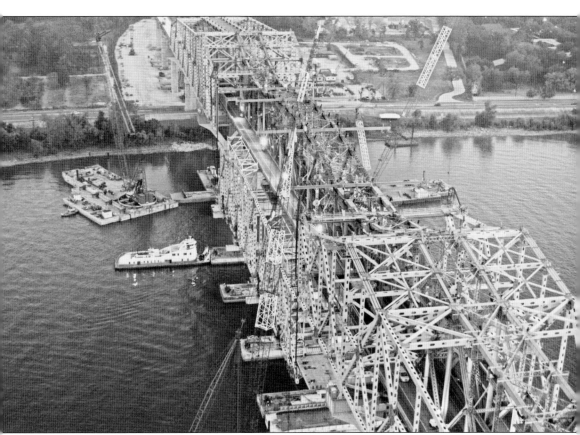

Contractors pre-assembled each span for the superstructure of the bridge on four barges connected by three sectional barges. Span 2 was 503 feet long and weighed 2,550 tons. Span 3 was the 100-member bridge segment measuring 528 feet long by 114 feet high and weighing 2,650 tons. Span 4 was 528 feet long and weighed 2,758 tons. Frames stabilized each bridge segment as it rose into place. (Louisiana TIMED Managers.)

Mike Neyman, assistant resident engineer for LTM, inspects the "birdcage" of the bridge, walking the line between the original bridge on the right and the expanded vehicular lanes on the left. From that vantage point, inspectors have a bird's-eye view of three modes of transportation: ships, trains, and automobiles. (Louisiana TIMED Managers/Shane Peck.)

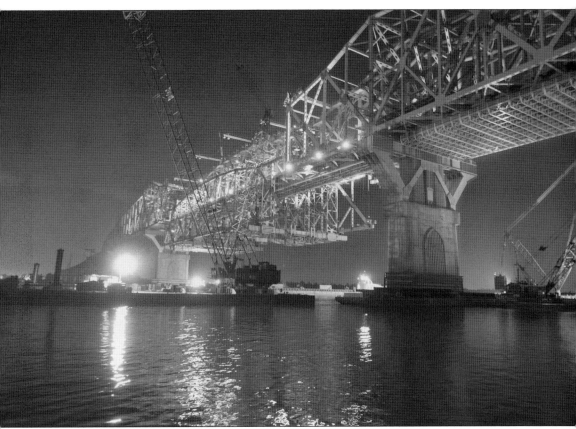

The installation of Span 3 in June 2010 was known as "Big Lift No. 1." Installers used hydraulic strand jacks to lift the bridge segment and the stability frames approximately 135 feet. Once lifted, segments were skidded 13 feet toward the existing truss using four jacks. Contractors placed the segments in their final positions, then lowered the stability frames back down to the barges. "Big Lift No. 2" for Span 2, seen here, did not require lateral movement. Instead, the span was lifted directly into its position. This lift occurred at night, when the bridge could more easily be closed to rail and vehicular traffic. (Louisiana TIMED Managers.)

Shane Peck, communications director for LTM, joined the engineering inspection team for a walk on top of the bridge. Keeping the public informed of lane closures and special events throughout the widening project has been part of the construction plan from the design phase. Peck's personal knowledge of the construction project guides his communication to the public through television and newspapers interviews and through the project's award-winning Facebook page. (Louisiana TIMED Managers.)

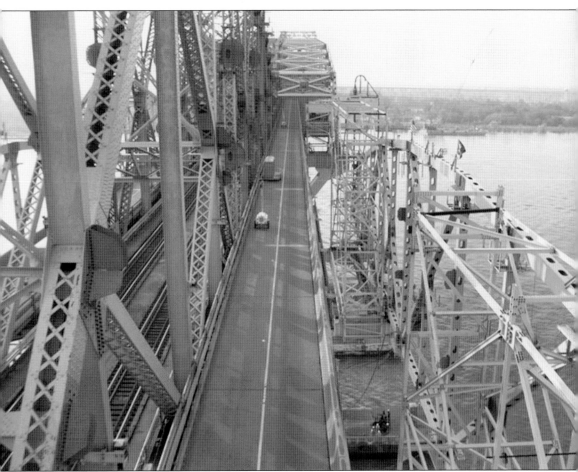

"Big Lift No. 3" for Span 4 was achieved similarly to the first Big Lift. The advantages of using the span-by-span assembly method were that it eliminated the need for falsework in the middle of both of the navigable spans, minimized the number of river closures to accommodate installation in the navigation or auxiliary channels, and increased production due to easier and safer connection accessibility on barges. (Louisiana TIMED Managers.)

Construction and inspection work on the bridge is not for people with acrophobia. Although workers are securely tethered, the threat of falling is always present on the job site. Clement Edward Chase, who in 1931 became a partner in the corporation of Modjeski, Masters, & Chase and worked on the Huey P. Long Bridge, died in 1933 after a fall from the Delaware River Bridge, where he was planning the construction of a high-speed electric passenger railway. (Louisiana TIMED Managers/Shane Peck.)

Bridge inspectors pause to cast their shadows above the once isolated and swampy batture lands. "To love a swamp, however, is to love what is muted and marginal, what exists in the shadows And sometimes its invisibility is a blessing. Swamps and bogs are places of transition and wild growth . . . where organisms and ideas have the luxury of being out of the spotlight, where the imagination can mutate and mate, send tendrils into and out of the water," writes Barbara Hurd, in *Stirring the Mud: On Swamps, Bogs, and Human Imagination*. (Louisiana TIMED Managers.)

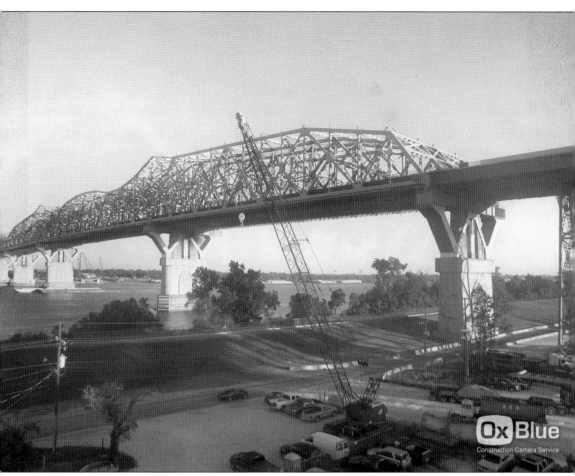

TIMED program personnel held multiple public outreach and educational events to explain the bridge design and construction. One event was with the members of the Girl Scouts, Louisiana East. The girls met on the levee near the bridge and learned about aspects of bridge design such as tension and compression. They built a human bridge, with each girl representing a different piece, and they learned how forces move through the parts. (Louisiana TIMED Managers.)

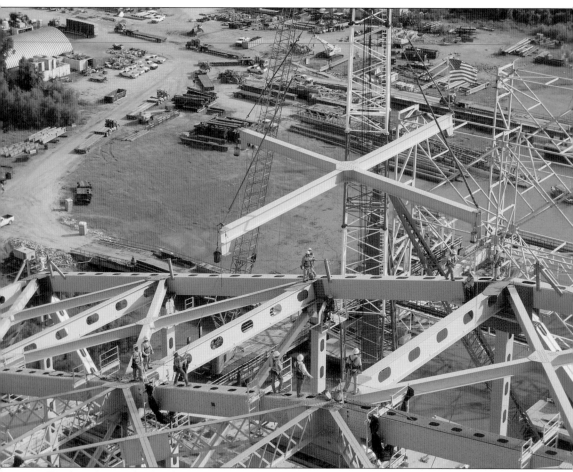

Workers lower the final piece of steel into place on the main bridge expansion. As a crane suspended the steel members, installers guided them into place from each of the four corners. The American flag proudly goes along for the ride, a symbol of the nation's progress and ingenuity. (Louisiana TIMED Managers.)

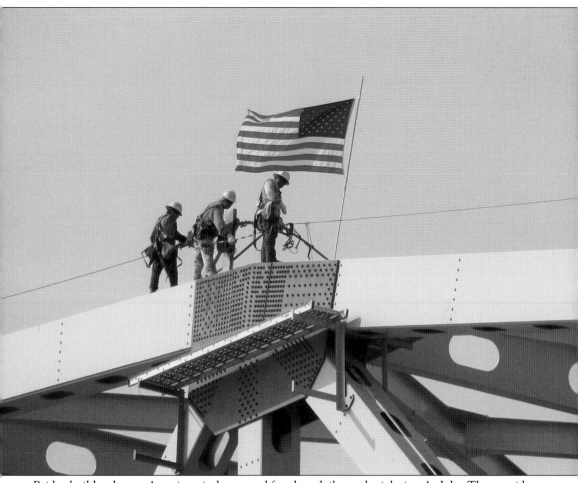

Bridge builders honor American industry and freedom daily on the job site. As John Thune said, "I believe our flag is more than just cloth and ink. It is a universally recognized symbol that stands for liberty, and freedom. It is the history of our nation, and it's marked by the blood of those who died defending it." (Louisiana TIMED Managers.)

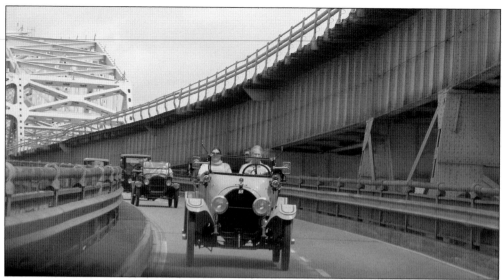

These 1930s cars were some of the last vehicles to cross the Mississippi River using the old lanes of the Huey P. Long Bridge. The smaller cars, of widths common at the time of the initial bridge construction, fit much better in the narrow lanes of the original highway than do modern automobiles and tractor-trailer trucks. The widening of the lanes and the addition of shoulders to the roadway will make the highway safer and will bring it to current Louisiana Department of Transportation and Development standards. (Louisiana TIMED Managers.)

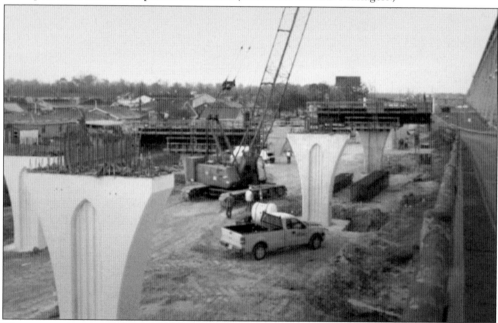

The approaches for the widened roads also require widening to smoothly transition vehicles to the new multi-lane highway. As part of the reconfiguration, new intersections with traffic signals at Bridge City Avenue and Jefferson Highway are being constructed. A new flyover ramp is being built to access Clearview Parkway from the bridge in the east bank–bound direction. To access Jefferson Highway, a separate ramp will be used. The piers shown here will support the new portion of the approach. (Louisiana TIMED Managers.)

On April 29, 2012, engineers switched traffic from the old lanes on the Huey P. Long Bridge to two new lanes in each direction. The switch occurred so that the old lanes could be removed and the new ones widened to three 11-foot lanes in each direction, plus shoulders. Commuters on both sides of the river have enjoyed the wider, less intimidating lanes. The lanes shown here are on the west approach, going toward the east bank. (Louisiana TIMED Managers.)

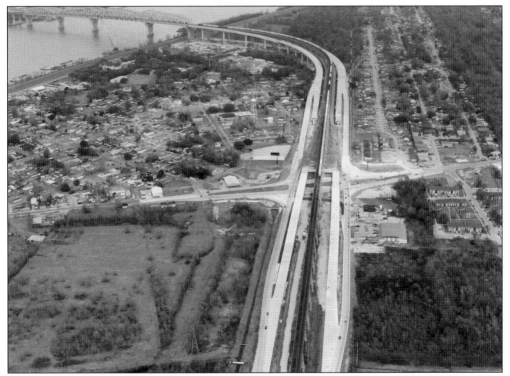

The final phase of the project involves building the roadways on and up to the bridge adjacent to the old lanes. In late August 2012, contractor KMTC began installing beams known as stringers that support the new lanes on the bridge. KMTC is a joint venture of Peter Kiewit Sons', Inc.; Massman Construction Co.; and Traylor Brothers, Inc. This is a view of the west bank approaches under construction. (Louisiana TIMED Managers.)

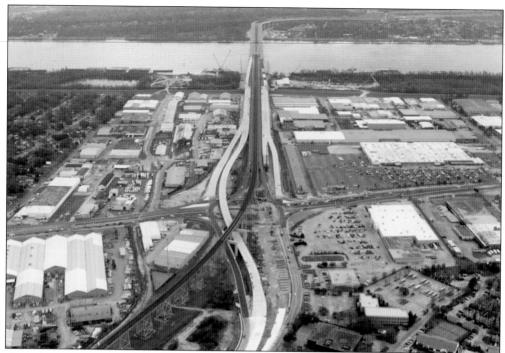

According to literature from the American Society of Civil Engineers, the move to the new lanes was termed "The Big Switch." Each of the new lanes on the bridge is approximately one foot wider after the traffic shift. Demolition of the old lanes began on April 30, 2012. This is a view of the east bank approaches under construction. (Louisiana TIMED Managers.)

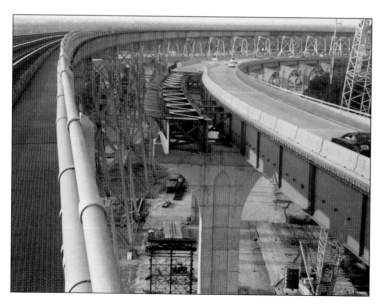

Cars using the new approach to the bridge drive by the adjacent construction area where contractors are actively completing piers and girders to support the additional lanes. Concrete Jersey barriers obstruct the view of drivers of the adjacent construction, but it is clearly visible from the ground. Once complete, three traffic lanes will be available to drivers. (Louisiana TIMED Managers.)

Because traffic control and an emotional connection to the iconic landmark were such large parts of the success of the widening project, the project team utilized many interfaces for public outreach. LTM regularly posts traffic and construction updates on the project's Facebook page (www.facebook.com/Hueypbridge) and Twitter feed (www.twitter.com/hueypbridge). LTM has also hosted public meetings to inform citizens of what to expect during the construction process. The project team won the 2012 Best Use of Facebook Award by the National Association of Government Communicators. (Louisiana TIMED Managers.)

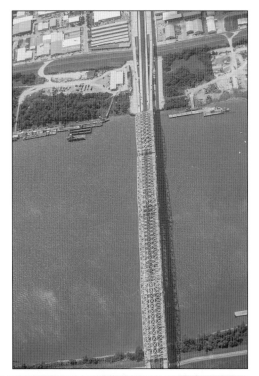

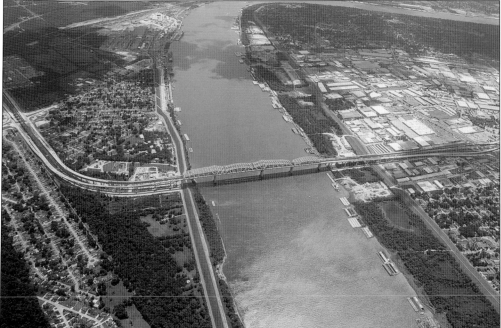

The Huey P. Long Bridge continues to bring economic development to the New Orleans area. The expanded bridge promises not only a safer, quicker trip across the river, but also signals further economic recovery. In October 2011, a shopping center just north of the Huey P announced it would add 15 new retail units in anticipation of additional traffic from the new bridge. (Louisiana TIMED Managers.)

DISCOVER THOUSANDS OF LOCAL HISTORY BOOKS
FEATURING MILLIONS OF VINTAGE IMAGES

Arcadia Publishing, the leading local history publisher in the United States, is committed to making history accessible and meaningful through publishing books that celebrate and preserve the heritage of America's people and places.

Find more books like this at
www.arcadiapublishing.com

Search for your hometown history, your old stomping grounds, and even your favorite sports team.